LAOS: LEGACY OF A SECRET

Thank you for your help to MAG

Front Cover: Cratered landscape, Xieng Khouang Province.

Irish Aid
Department of Foreign Affairs
An Roinn Gnóthaí Eachtracha

NOVOTEL
HOTELS
VIENTIANE

NTPC
Powering the Future

MAG is grateful to Irish Aid, Novotel Vientiane and NTPC for their support in funding this publication

LAOS: LEGACY OF A SECRET

photographs
Sean Sutton

texts

Dr Thongloun Sisoulith,
Deputy Prime Minister and Minister for Foreign Affairs, Lao PDR

Lou McGrath OBE

Sean Sutton and Tim Page

Dewi Lewis Publishing
in association with MAG

FOREWORD

Anyone looking through the photographs in this book cannot fail to be moved by them. War is always a tragedy. In the case of my country, the tragedy did not end when the war was over, and it has still not ended.

Laos is the country most affected by cluster munitions. During the Indochina war, over 270 million cluster munitions were dropped on Laos. Up to 30% failed to explode upon impact, and continue to kill and maim civilians, including women and children. These photos document that fact.

In the areas of Laos that were heavily bombed, a whole generation has grown up in the long shadow of the war. To these children, UXO and war scrap are as much a part of their daily lives as trees and rivers. The sheer ordinariness of the bombs and other ordnance in some of these photos is as shocking as the death and injury they cause.

But amidst the sadness, there is hope. UXO clearance – by many organizations, including MAG – has saved thousands of lives over the last 16 years. It has also enabled affected communities to make the most of their land and livelihoods. This work needs to continue; I extend my gratitude to all donors who make that possible.

We are pleased to see the success of the Oslo Process and we are proud to have played a leading role in the process to ban cluster munitions. We are hopeful that these weapons will have no further role in history, and that the images you see in this book will never be repeated again elsewhere.

H.E. Dr Thongloun Sisoulith, Deputy Prime Minister and Minister for Foreign Affairs, Lao PDR

In 1993 MAG received a request from the Mennonite Central Committee (MCC) for technical support and assistance to clear unexploded ordnance (UXO) in Lao PDR. The Mennonites' work had been the only humanitarian help the country had received from the outside world following the nine years of aerial bombardment it was subject to during the American war with Vietnam. Lao PDR is a landlocked country, relying mainly on an agricultural based economy. Its fields and mountainous terrain, its water sources as well as its architectural heritage had been rendered dangerously contaminated by vast amounts of UXO – from large unexploded bombs to small, live cluster munitions. While many in the world outside had knowledge of the legacy of wars faced by its neighbours Cambodia and Vietnam, there was little understanding of the devastating consequences the bombing had on the people of Laos.

It was to be 20 years between the last bomb dropped and MAG providing training and clearance support to the country. That lapse in time and the seasonal climatic conditions have all added to the difficulties in undertaking clearance. There is so much that one could write about this, and, above all, about the ingenuity and resilience of the Lao people. However, the images that Sean Sutton has captured over the years have honestly recorded that reality. His photographs tell a story of people living their normal daily lives, yet where the legacy of the bombing remains ever present. My words here could not do the same justice to what is a unique visual documentary of that legacy.

Despite the significant work undertaken in Lao PDR since MAG set up its programme in 1994, no-one involved is under any illusion of the clearance that still needs to be done. Things have, however, improved. Today Lao PDR has a greater national capacity able to deal with the UXO problem. The National Regulatory Authority (NRA) has responsibility for coordination of the clearance and ensuring high quality standards. MAG is also proud to have played a part in supporting the development of the national clearance organisation UXO Lao. MAG's own programme is reliant on Lao expertise throughout its structure, with only a small international presence.

What has been achieved in Lao PDR to date could never have been done were it not for the support of all those governments, trusts, foundations and individuals who have financially supported the clearance efforts. This book has been published in the year that the Convention on Cluster Munitions takes effect, a treaty which the Lao PDR government should be congratulated for adopting. My ongoing hope is that governments, whether they have obligated themselves under the treaty or not, will see fit to contribute to the clearance of Lao PDR in order to ensure we can provide a peaceful and fearless future for this and the next generation of children in this amazing country.

Lou McGrath OBE, Chief Executive, MAG

UXB UXO

These letters seem like an unintelligible code until you get to grips with just how deadly their symbolism is. UXB stands simply for unexploded bombs. UXO stands for the complexity of all unexploded ordnance, including shells, mortars, rockets and air-dropped munitions.

MAG (Mines Advisory Group), a UK-based humanitarian organisation specialising in the safe removal and destruction of dangerous UXO, has spread its wings in Indochina, taking in the country of Lao PDR, the People's Democratic Republic, the former Kingdom of Lane Xang. The land of a thousand elephants and white parasols finished the conflicts of the late 1960s and early 1970s with the status of the most bombed place ever on the planet. There were thousands of sorties and millions of tons of ordnance dropped in an attempt to close the Ho Chi Minh Trail, which ran into eastern and southern provinces. Lao PDR is a triple-canopied tropical forest studding precipitous sharp mountains, with raging monsoon torrents in the wet season, and arid in the dry season. Many of its inhabitants are indigenous mountain tribespeople; hunter-gatherers dependant on moveable agriculture.

The cure to prevent more casualties has been education and awareness programmes in a country still rife with illiteracy. War did little to improve the lot of these mountain-dwelling tribesfolk.

The PDR remained a closed shop to the outside world, much less to tourism, pretty much until the turn of the new millennium. Its infrastructure was virtually nonexistent. There was little reason to develop the hinterland. Now mineral strikes have put crews into former no-go areas which once funneled the Ho Chi Minh Trail, while tourists take bus trips to the Plaine des Jarres and venture into the wilderness of Saravane and Pakse.

Sean Sutton is a battlefield archaeologist, with an inquiring eye that can determine erstwhile air strike or artillery crater, the scars to landscape both rural and urban and its inhabitants and victims.

It is the beauty in the detail that always homes one into Sean Sutton's work; it catches you unawares and demands restudying. The details are often surprising and terrifying. The harbingers of death, destruction and mutilation are there, lurking; a terrible fixation, a fascination with the heirlooms of modern heritage, the detritus of modern conflict and war. Take a close up of a Hmong lantern created out of a mortar round, for example. Look closer at the odd looking pirogue; what would have been a hollowed out log is now fashioned from aircraft long-range drop fuel tanks or napalm canisters.

When you are a photographer you are privileged to visit places ordinary folk cannot or do not see. Remote cultures are now the backdrop to your frames. You start to have the country's landscape, its peoples, unfold before you. It is hard to describe the beauty of Lao PDR: the Plaine des Jarres with its

mystical urns, the mountain cordillera that fronts Vietnam; in the south on the plateaus you find the return of wild elephants and tigers.

As photojournalists we spend much time actively pursuing being in the wrong place at the right time or is it vice versa? We hope for the best and worst to happen before our eyes, before our cameras. We hunt these moments assiduously, we revel when we stumble into them, then we are shocked and use the viewfinder as an excuse for our presence. Lao PDR is not a small country, it stretches the length of the Mekong from China to Cambodia; getting about can be a fraught escapade. It is a freak chance for Sean to have come upon the blind sole survivor of a band of scrap metal hunters who had been attempting to break apart an old 250lb bomb when it exploded.

Scrap is worth a lot to these people. Their subsistence level economy means a bomb this large would have provided income for weeks – at $1.17 a kilo for copper, $0.82 for aluminium and, more insidiously, the $0.35 bounty on the explosives, it's clear why the temptation could be so great. The blinded scrap hunter leads Sean to his colleagues' remains; the Ho Chi Minh Trail still claims victims 35 years after liberation.

You are never sure how close you should get when you take pictures of the dismantling of munitions. The locals appear to do it with impunity. There is a haunting image of a villager taking apart a cluster bomb with a hammer, the children scattering in the background. The old man wants the bomb for an oil lamp. Will he survive the effort and, if so, how many lamps will he survive to light in the future? Capturing these intimate frames requires a sang-froid, a nerve like no other. It's actually beyond terrifying, and I can think of few photographers who document this in such fraught places for so long or so thoroughly. And all of it done in the most compassionate and genuine way.

We can only applaud the work done here and by MAG's donors and supporters.

Tim Page, photographer

Between 1964 and 1973, during the war with the United States, the North Vietnamese used a network of supply lines, known as the Ho Chi Minh Trail, running from North Vietnam through the jungles and mountains of neighbouring Laos and Cambodia. In an effort to staunch the flow of troops and weapons the U.S. dropped more than two million tons of bombs on Laos, including more than 270 million cluster bomb submunitions. The U.S. war effort in Laos was kept secret from Congress and the American people, full details of the scale of the bombing sorties only becoming declassified in the 1990s.

By the time the aerial campaign ended in 1973 more bombs had been dropped on Laos, since renamed Lao People's Democratic Republic, than the Allies dropped on Germany and Japan combined during World War II. Many of these bombs failed to explode when they hit the ground, leaving the landscape littered with hundreds of thousands, perhaps even millions, of unexploded bombs, as lethal today as when they fell from the sky three decades ago.

Dubbed "bombies" by Laotian villagers, these often brightly coloured cluster bomb submunitions are still found in the clefts of bamboo branches, by children playing in shallow dirt, or in the fields where farmers till the soil by striking the earth with a hoe.

Since 1974 more than 20,000 people, many of them children, have been killed or injured by bombs or other unexploded ordnance in Lao PDR. Today, the lives of about 300 Laotian people are still devastated each year by the deadly remnants of this war.

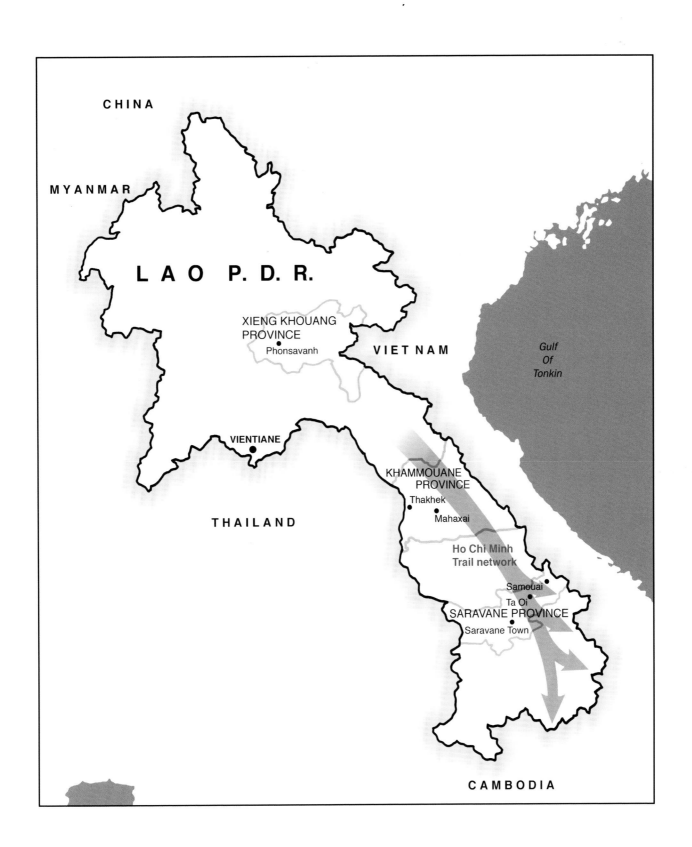

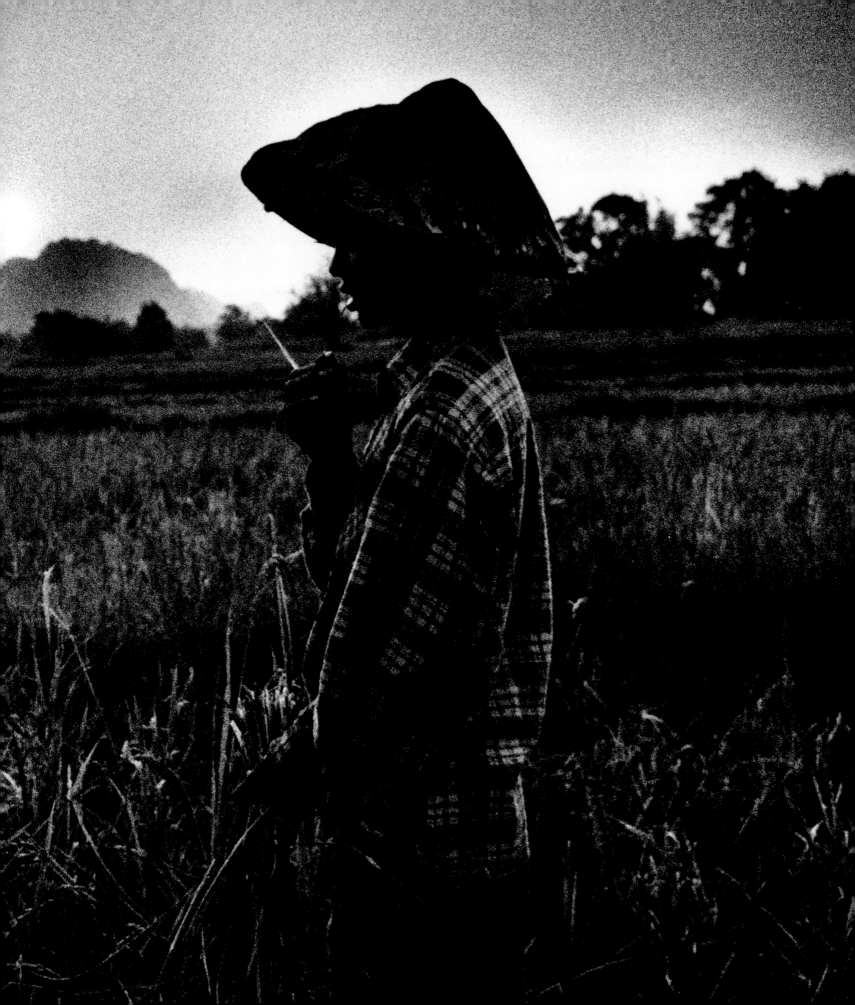

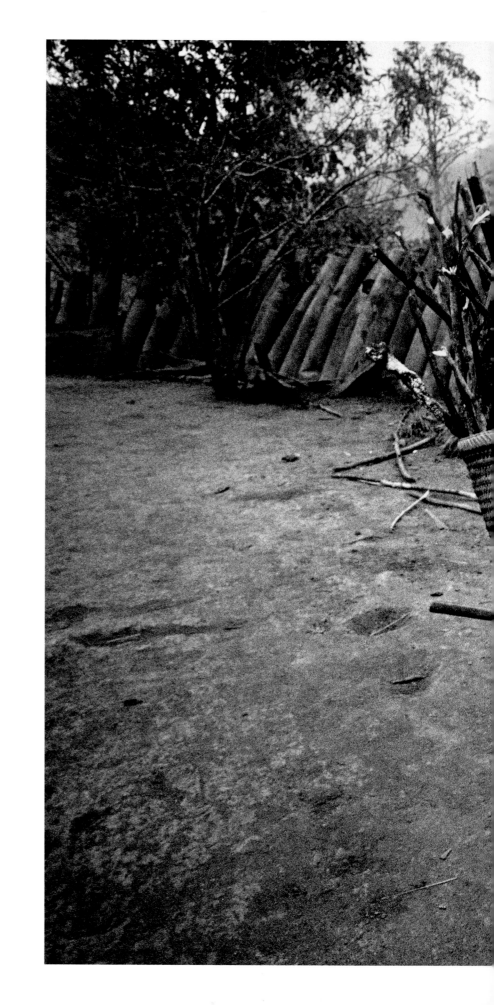

Previous page: Misty morning
in Khammouane Province.

Right: Boys walk past a fence
built out of cluster bomb units.
Xieng Khouang Province.

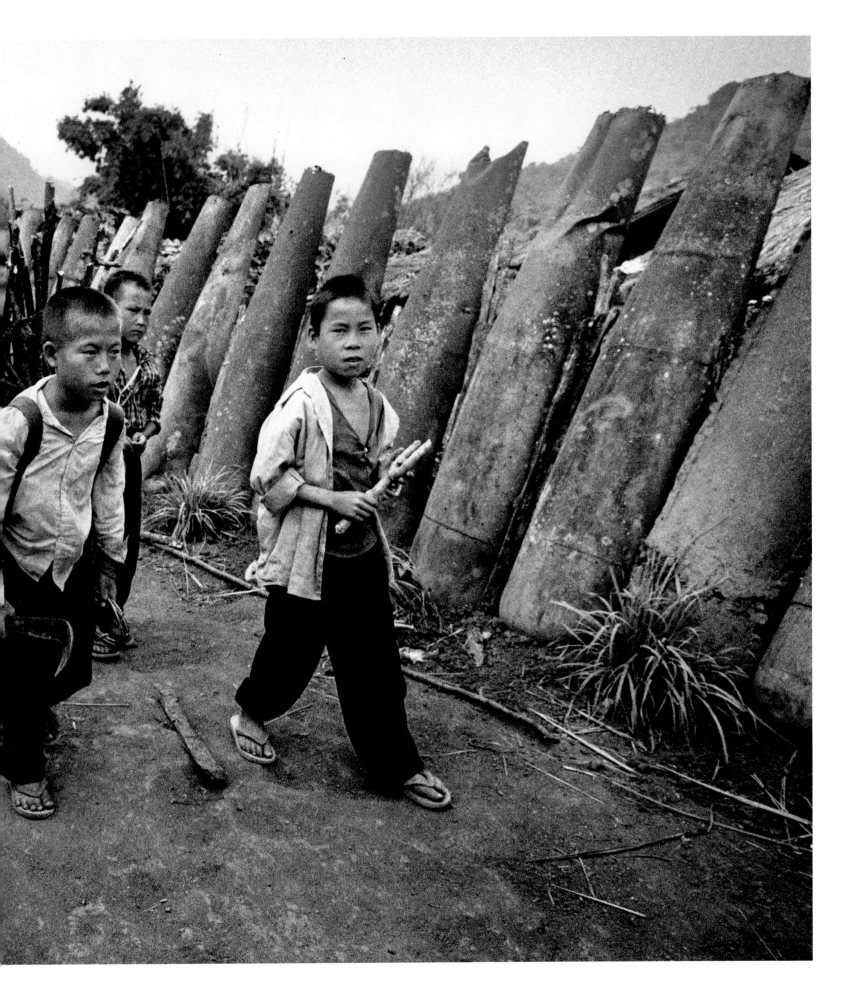

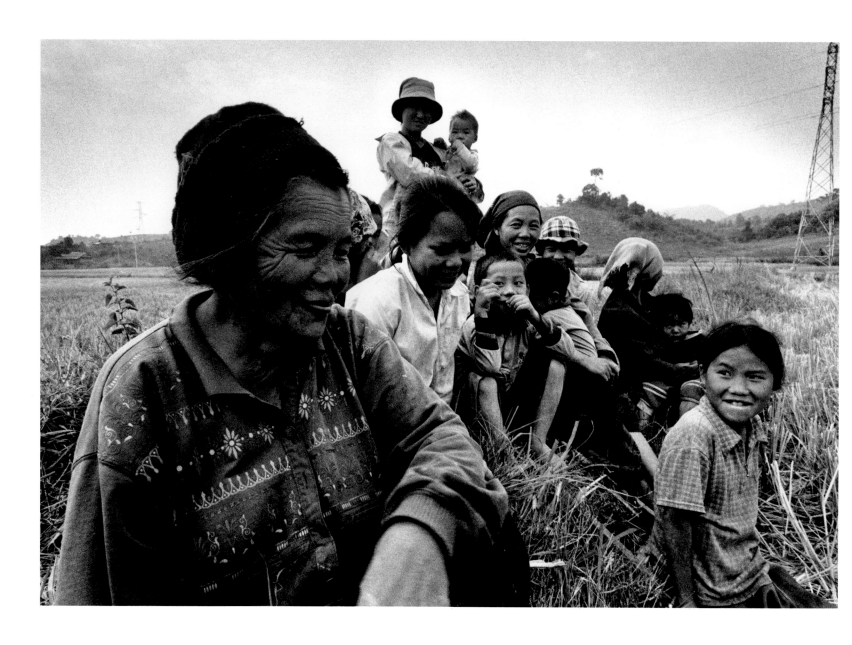

Above & right: A grandmother with some of her family after
a long day's work harvesting rice. Xieng Khouang Province.

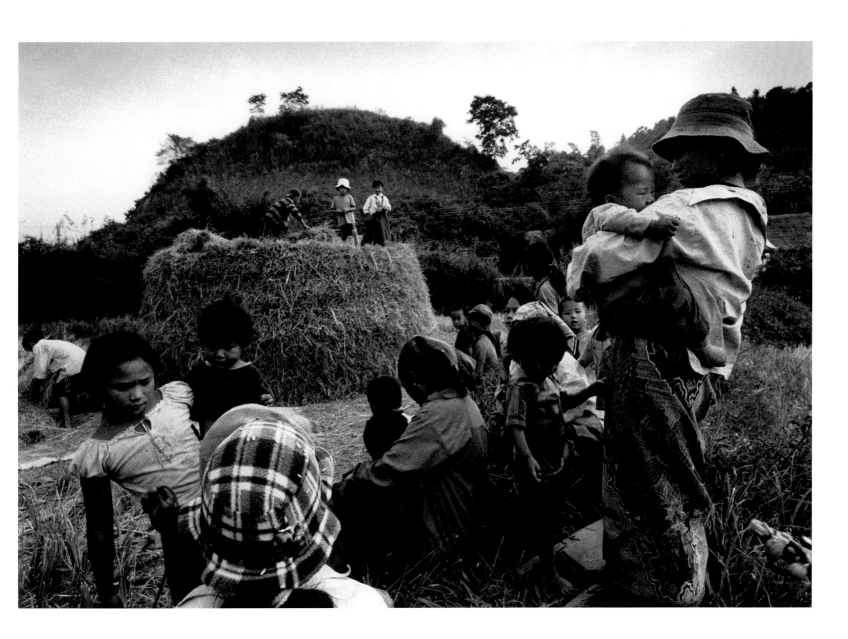

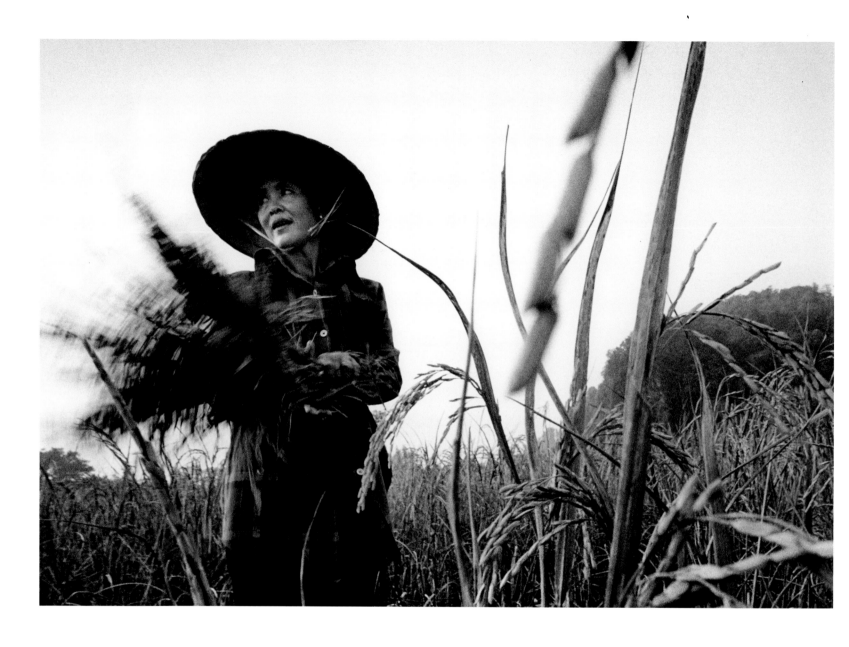

Harvesting rice. Most people in Lao PDR are subsistence farmers.
If the harvest fails they go hungry. Khammouane Province.

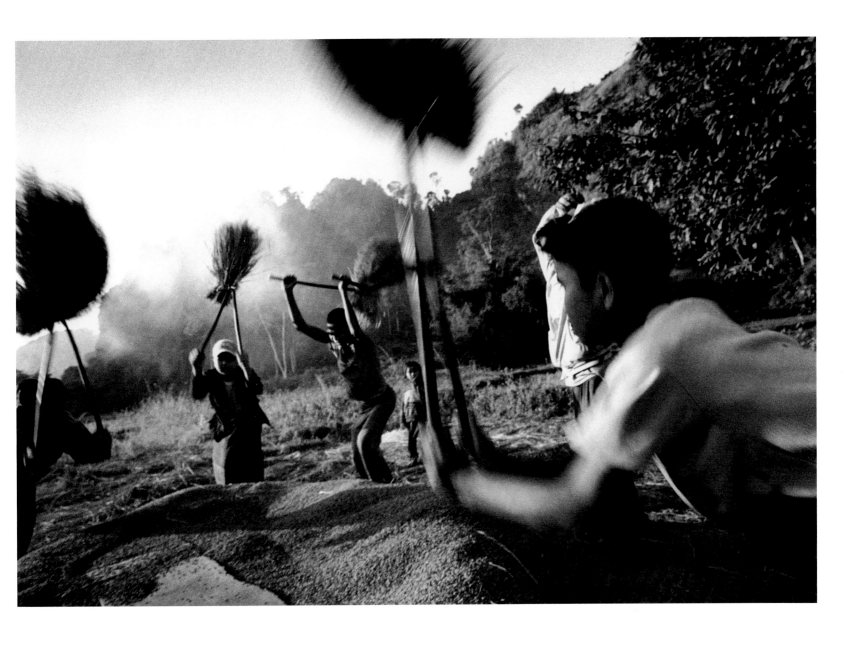

Beating out the rice grains.
Everyone helps out during the harvest.

Saykham and Oakkhame. "Before we didn't have enough and now we have. Before we would get 20 bags — now we get 50. That's thanks to the channel bringing water in the dry season. Also the land is safe! I was scared before. There were bombies all over the place. We found them every year. Now they are gone. We used to spend a lot of time in the forest looking for food. Now we get enough from our farm — it is much easier." Khammouane Province.

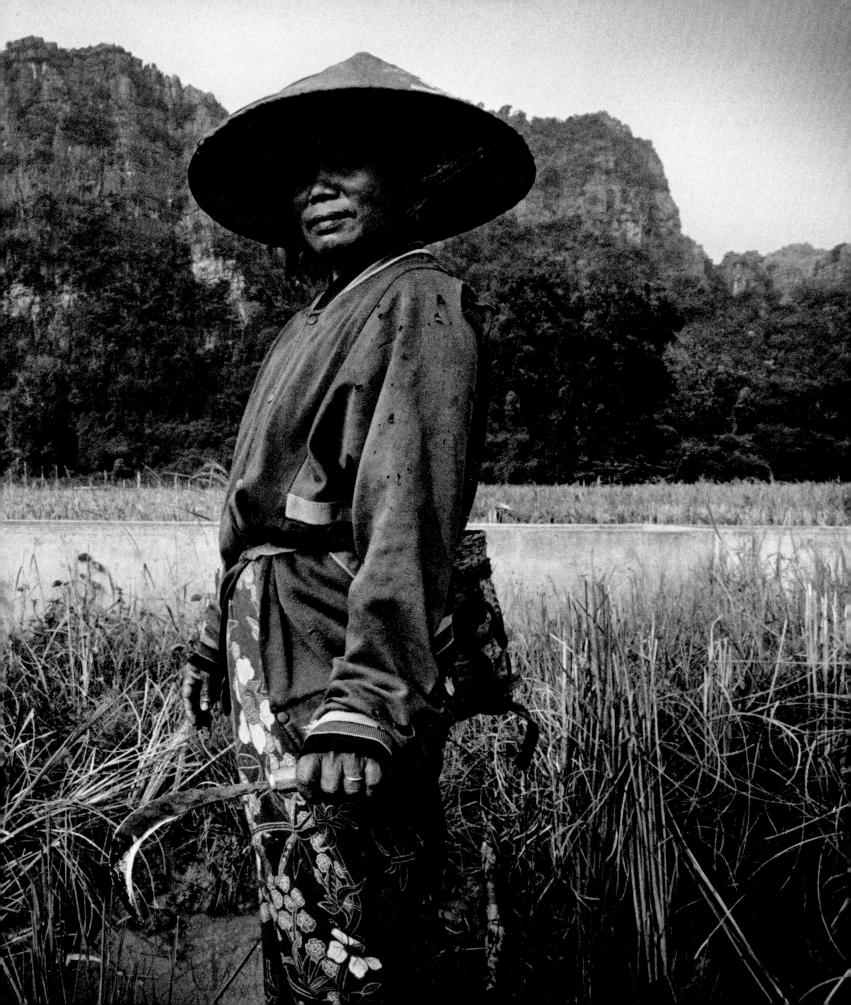

Forty-four-year-old Mr Sulit has five children and is the sole carer since his wife passed away seven years ago.

MAG has cleared a new rice paddy for the family. "Before I could grow 10 bags of rice but since MAG cleared the new paddy we can get double that, about 80 kilos more a year. That's the difference of having food or not for half the year. Next year will be even better as we didn't have time to cultivate all the land before the planting season this year. We might even be able to sell some rice if we are lucky." Khammouane Province.

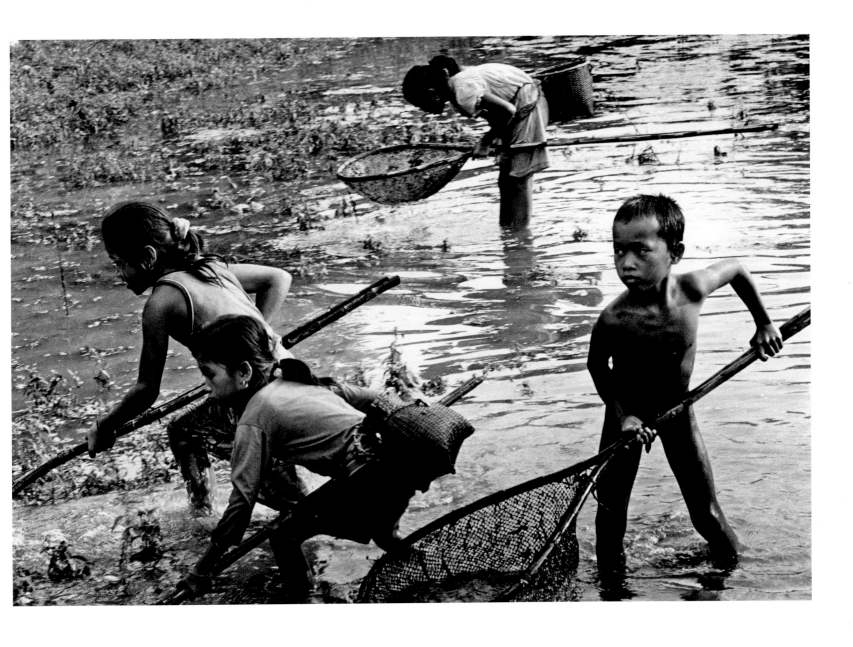

Children fishing for snails and frogs. Many children
in rural areas spend their time foraging for food and
working in the rice paddies rather than going to school.
Khammouane Province.

Mrs Bei raising ducks in Ban Natin. Khammouane Province.

Mr Ten with his wife Nah. "When the war stopped it was
silent and everything was destroyed – even the cooking pots
were gone. But that was a long time ago. Now Americans
come here as friends. He laughs: "My holder for my knife
here is made from an American cluster bomb tube. We
couldn't manage before because we couldn't grow enough
rice. But since MAG came here that has changed. Now me,
my wife and another eight people live from these paddies."

In this village MAG cleared 52,191 square metres and found
and destroyed 27 items of unexploded ordnance. The cleared
land has now been cultivated and directly benefits 48 people.
Khammouane Province.

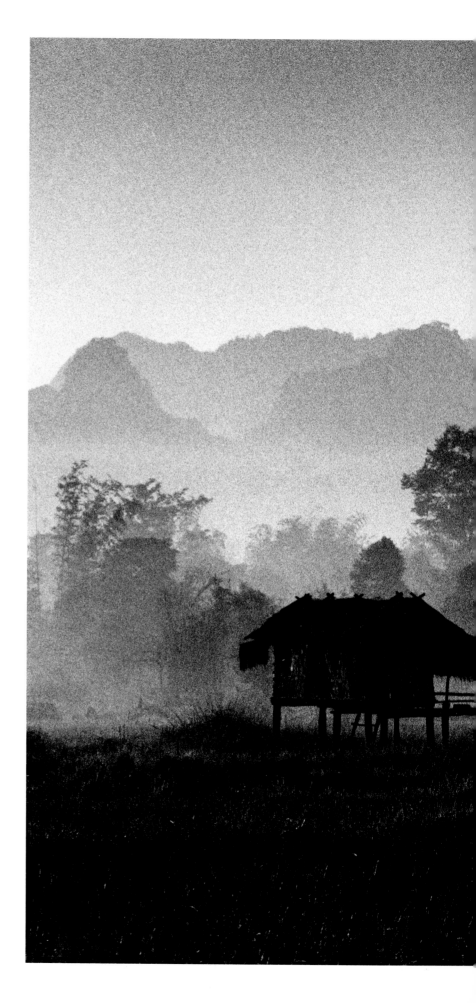

Paddies at sunrise along the
former Ho Chi Minh Trail.
Khammouane Province.

Following pages, left:
Sixty-six-year-old Nyot Keomanee
remembers the war years with
clarity. "We used to hide in
these caves for much of the time.
Sometimes the planes would
come as low as the bamboo –
then boom – they would drop
their bombs. Other times they
would be high up and drop lots
and lots of bombs. It was very
terrible and many of us died."

Following pages, right:
Retired soldier.

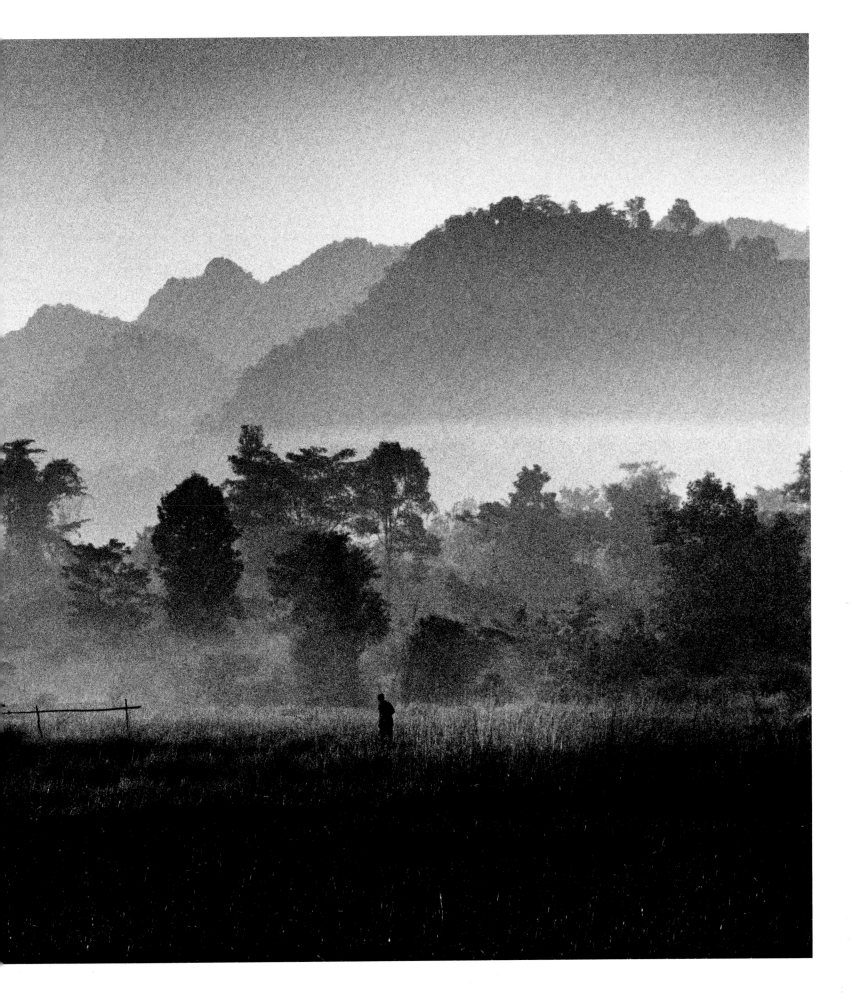

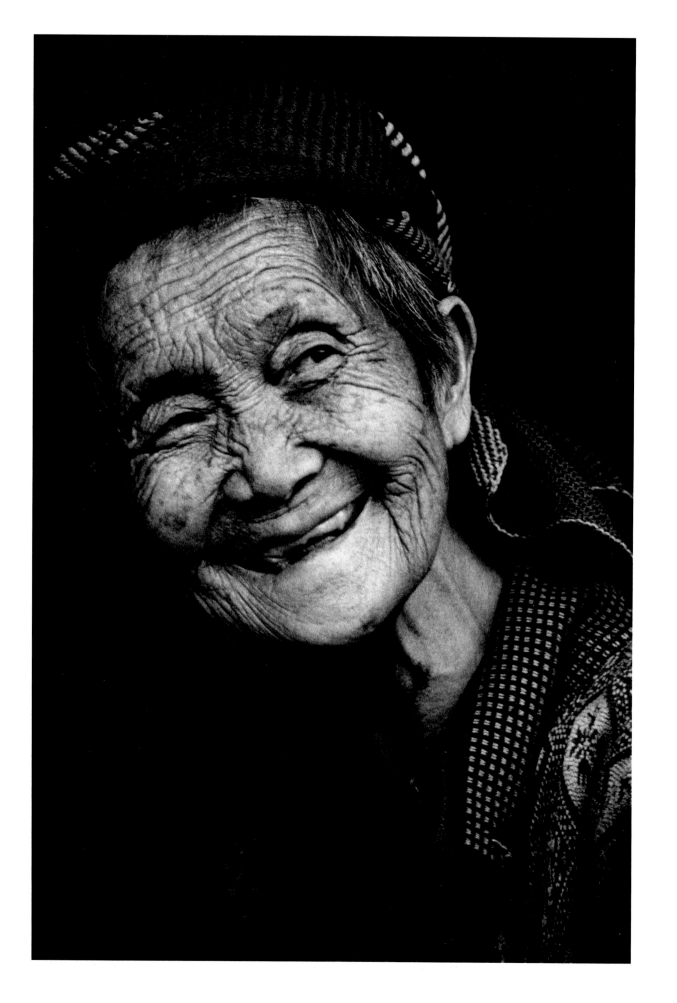

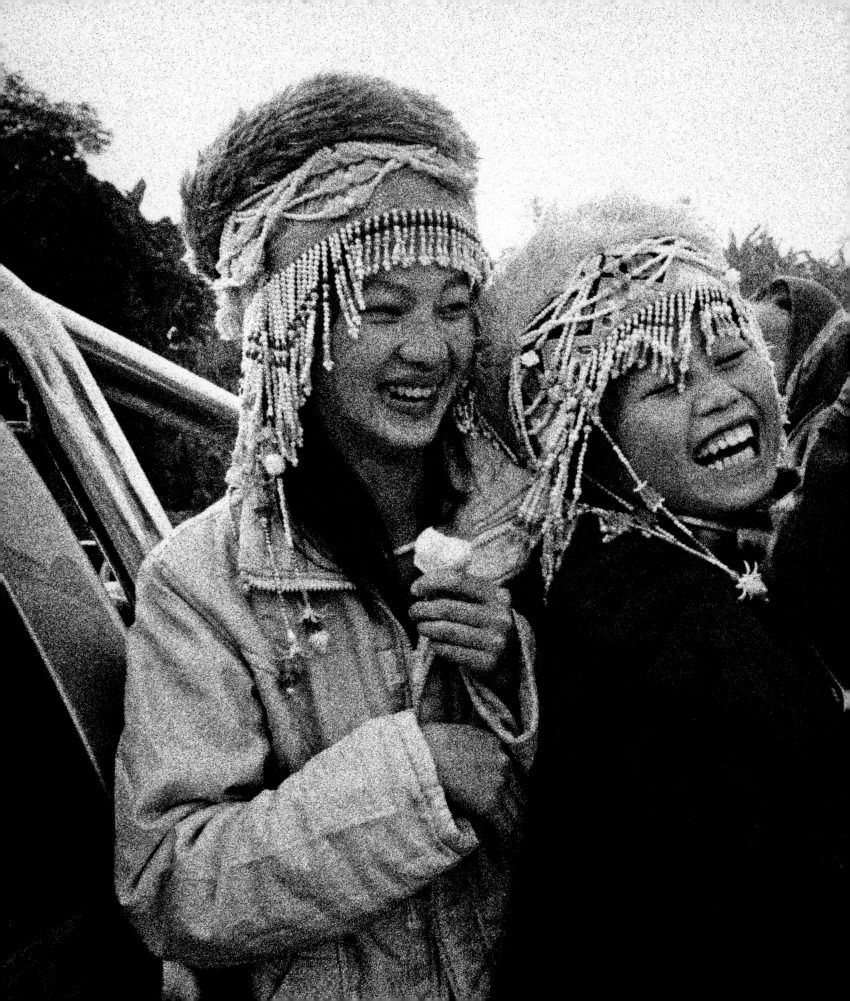

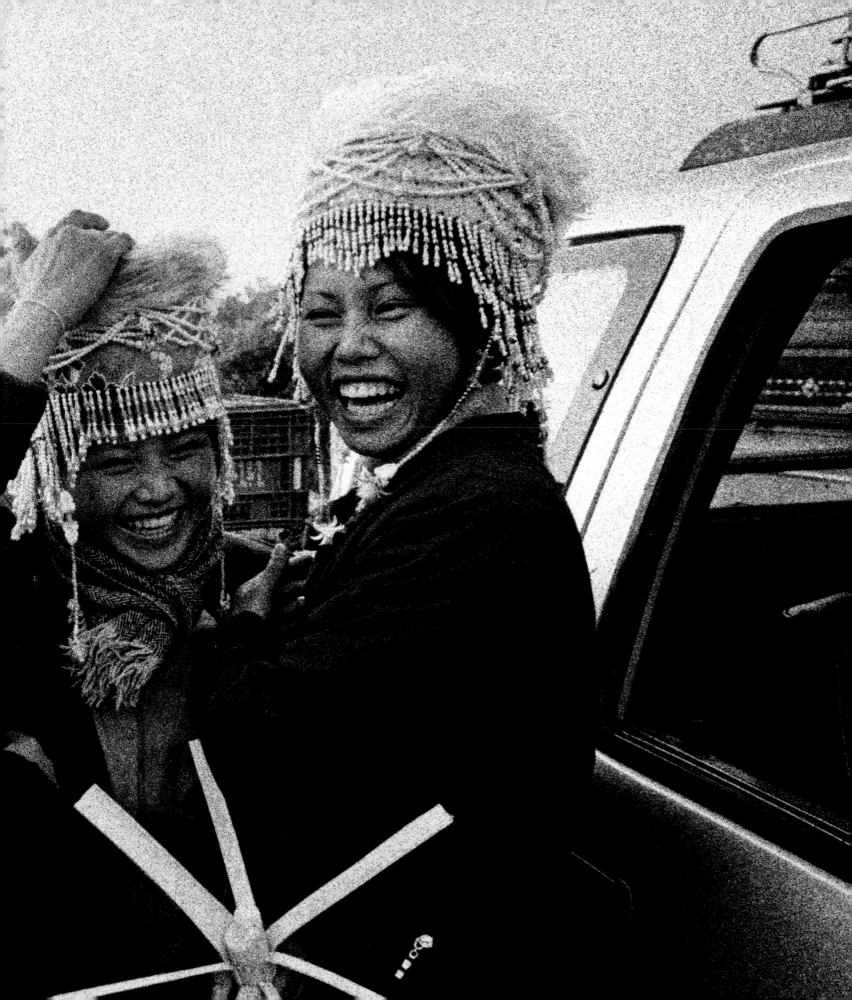

Previous pages:
Hmong girls try out their new traditional head dresses to be worn during match-making games in the wedding season.

This page: Monks in front of the only old Buddha image that survived the war in the Province. The temple was destroyed but the statue miraculously survived, suggesting to locals that it has great power. All photos: Xieng Khouang Province.

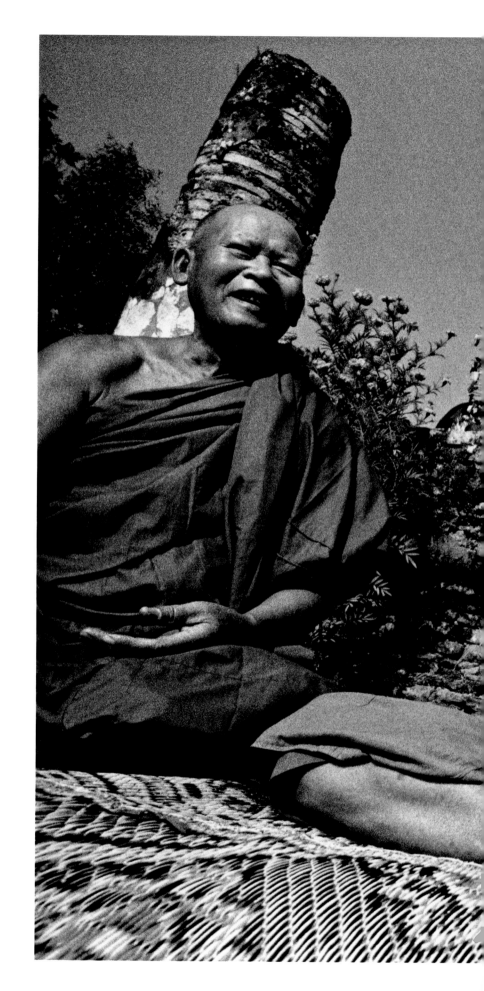

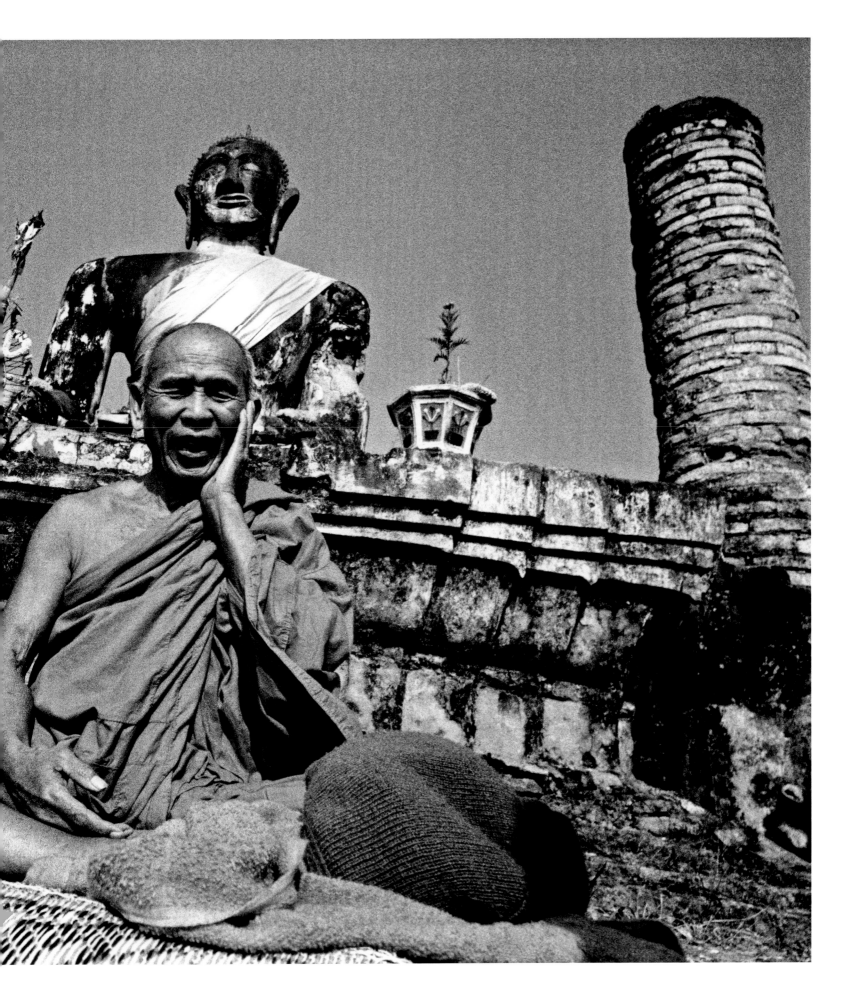

Young monks at Mahaxa temple.
Khammouane Province.

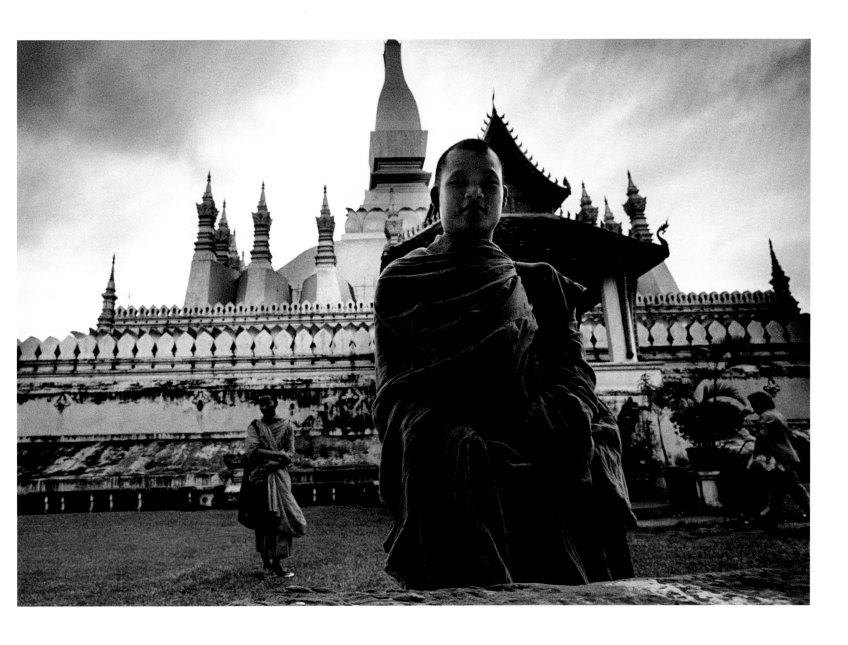

Pha That Luang temple in
Vientiane. The temple holds a
special meaning in Laos as it
has come to be the symbol of
the Lao nation. Vientiane.

A bomb that was dropped outside
a shop at least 30 years ago. The
shop sign advertises cold beer.
Xieng Khouang Province.

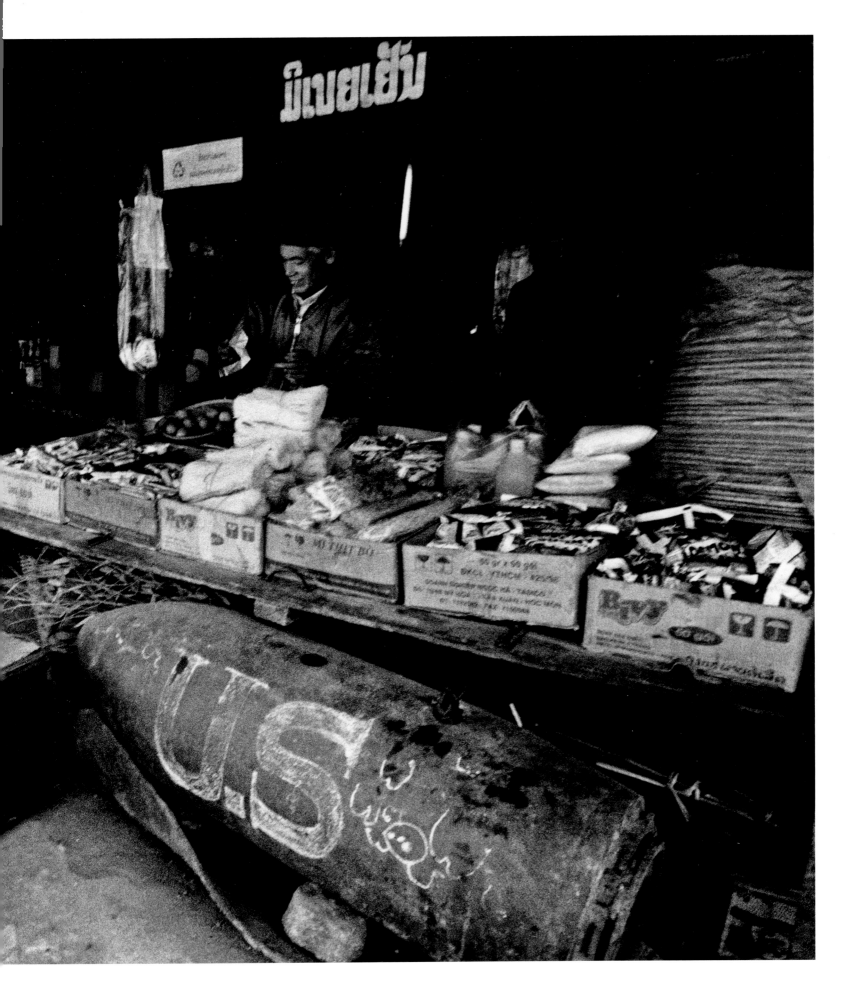

Celebrating Buddhist Lent.
Mahaxai temple.
Khammouane Province.

Following pages:
Villagers walk though one
of the Plaine des Jarres sites.
"These jars belong to us," they
said. "Our ancestors made them
to store lao-lao." Lao-lao is a
locally produced wine.
Xieng Khouang Province.

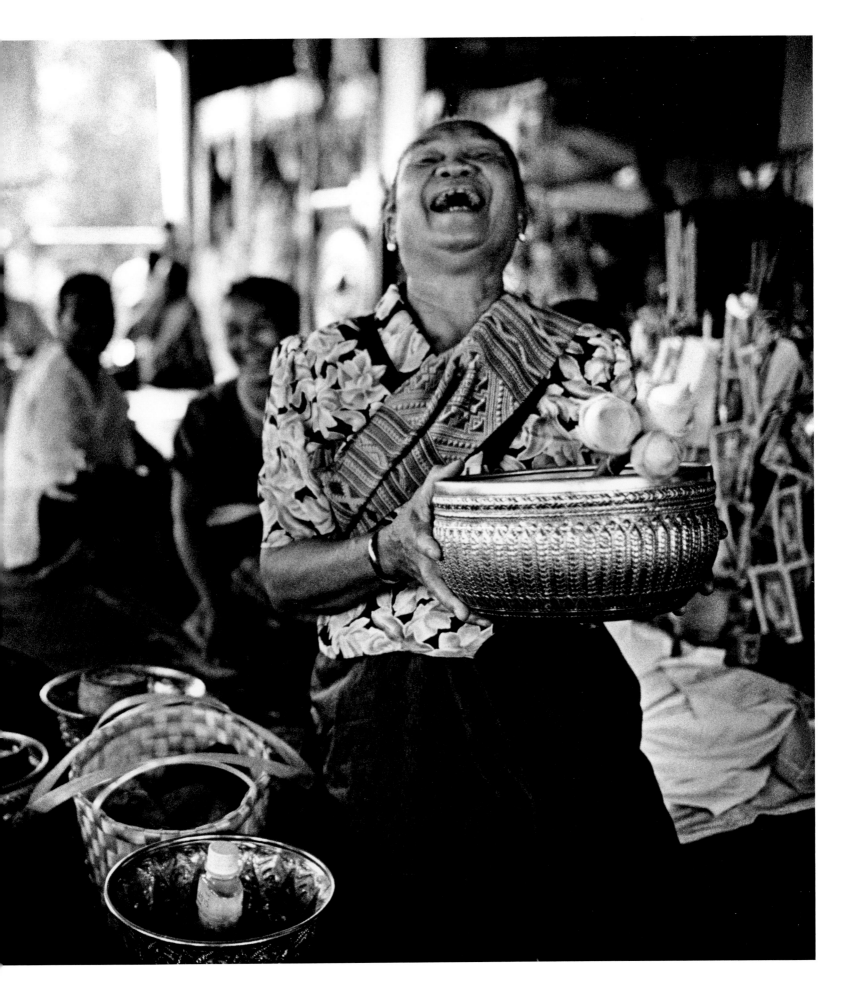

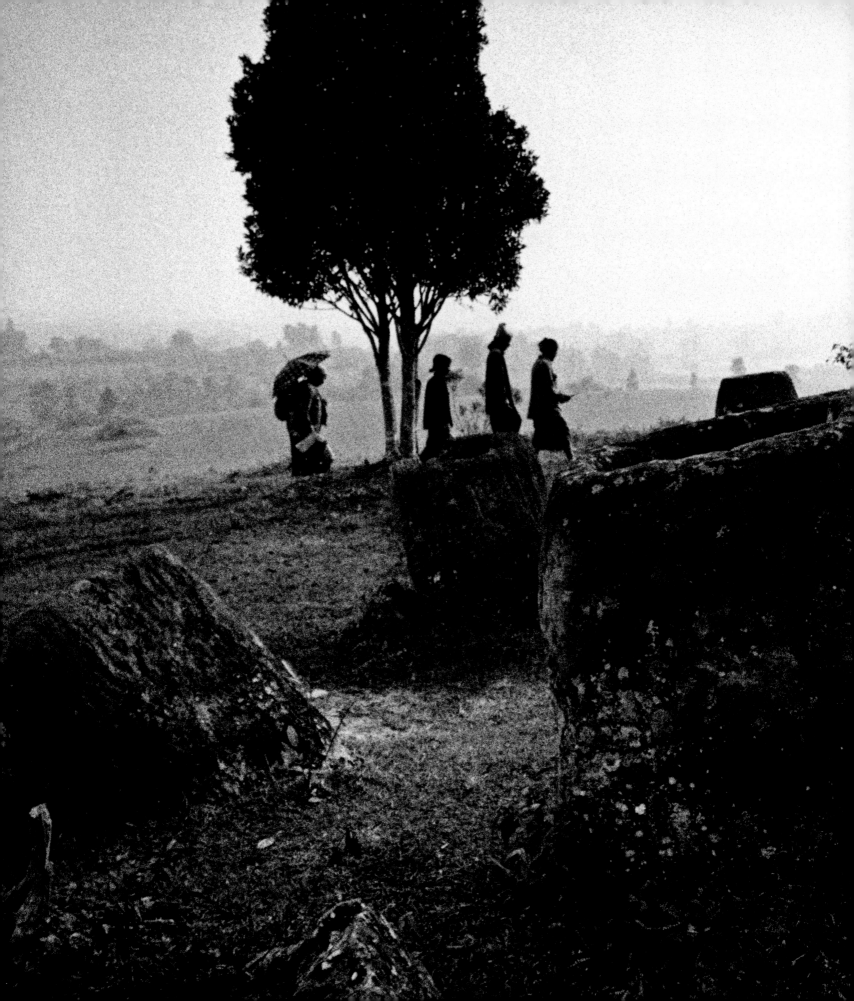

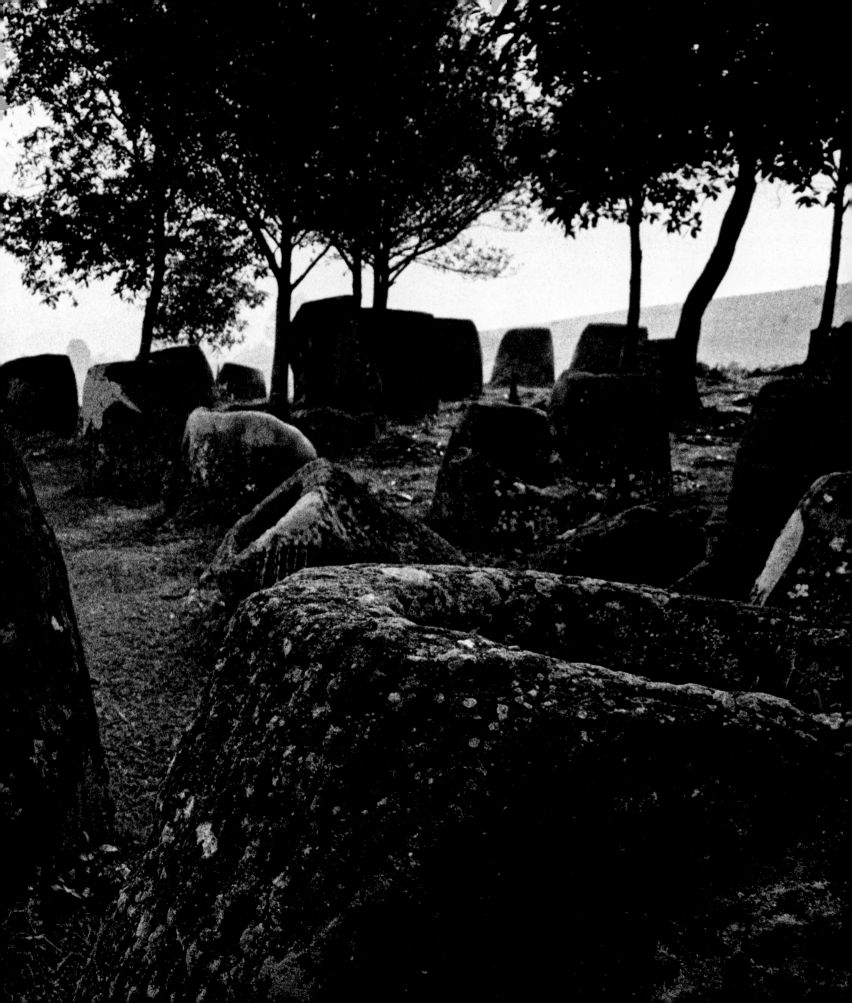

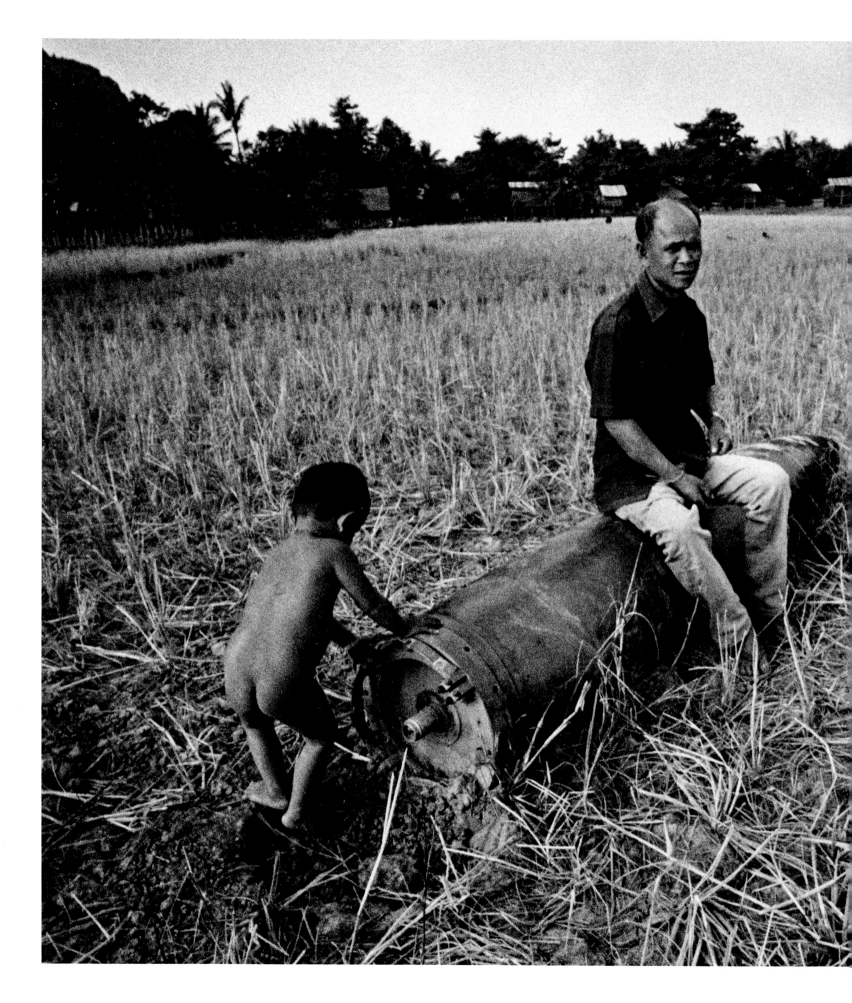

A 2,000lb bomb
in Phanop village.
Khammouane Province.

Following pages:
Part of an aircraft wing lies in
a Temple in Phanop village.
"We keep it here to remind the
children of what happened,"
the monk said. "This belongs
to the village and if one day we
badly need money we might
sell it for the scrap value."
Khammouane Province.

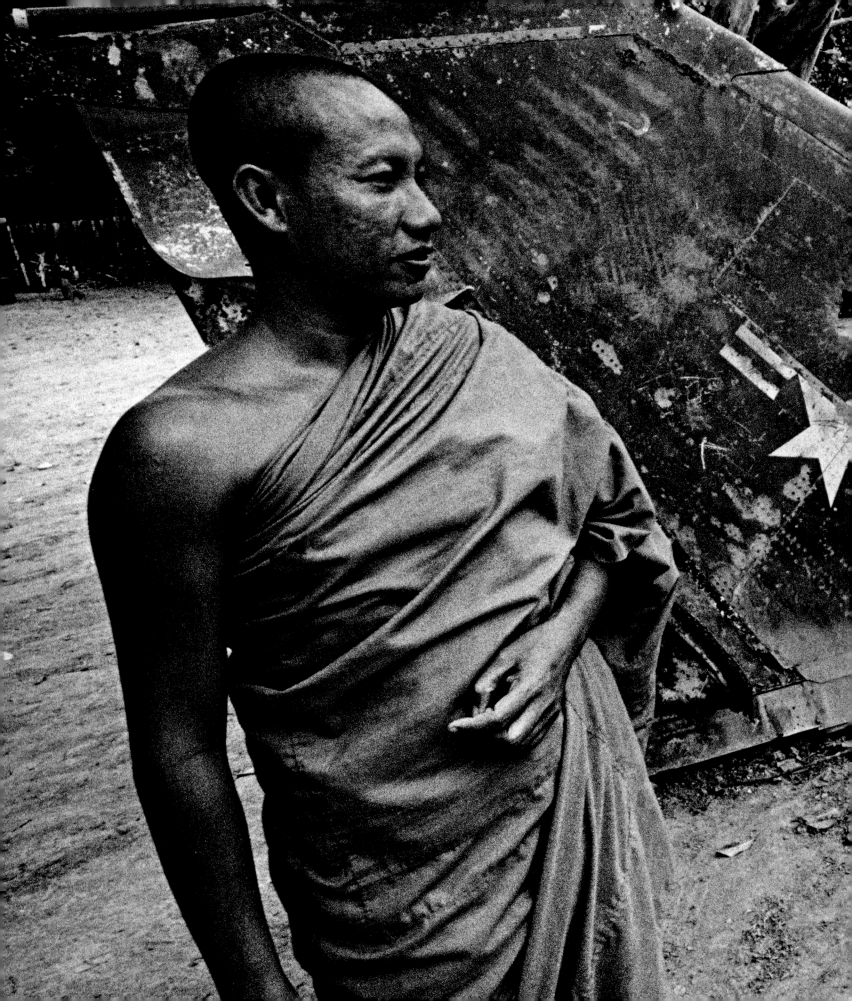

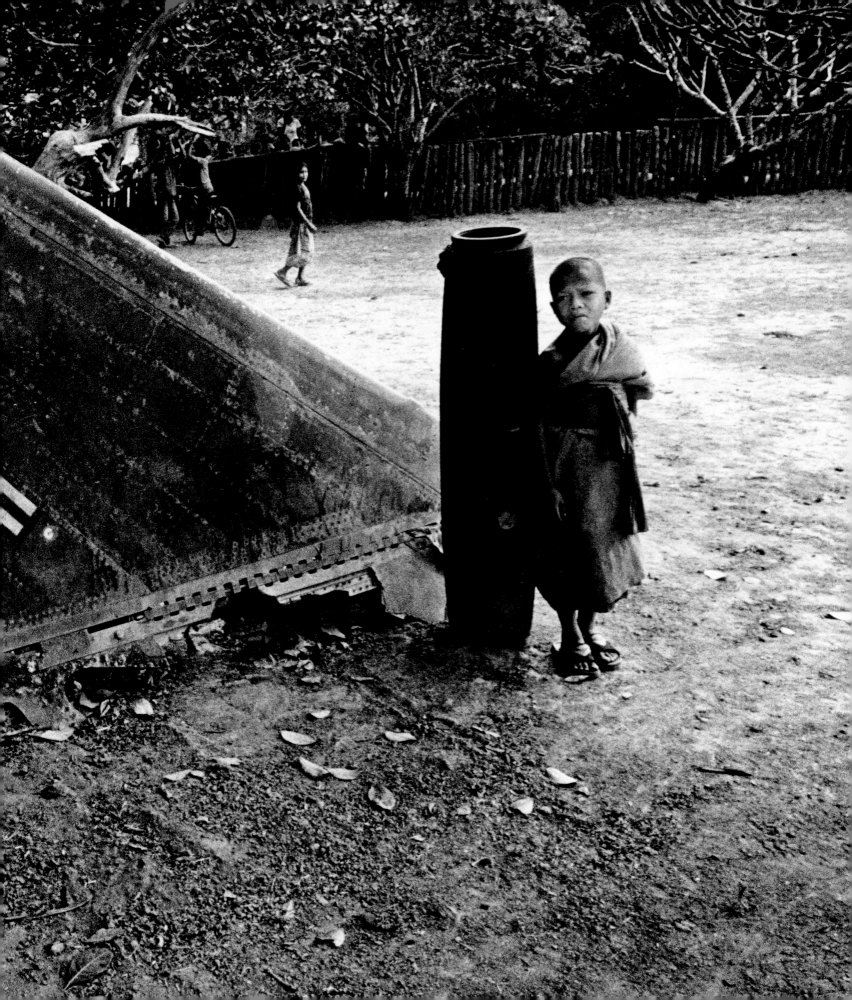

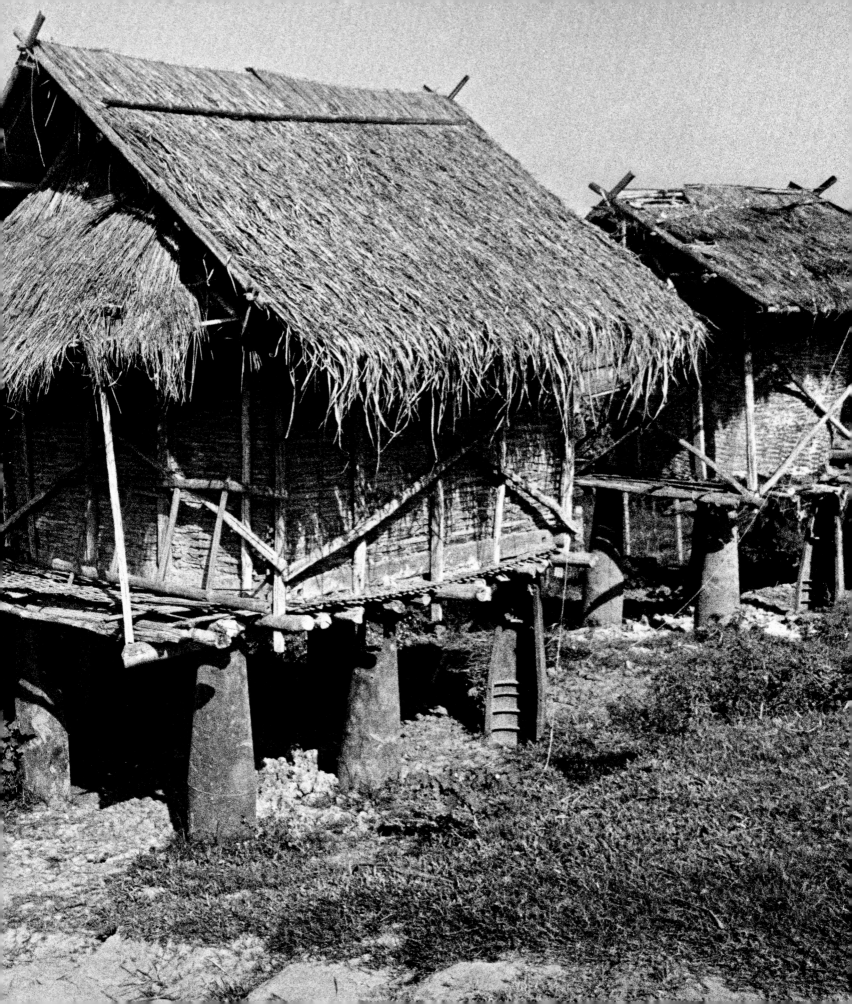

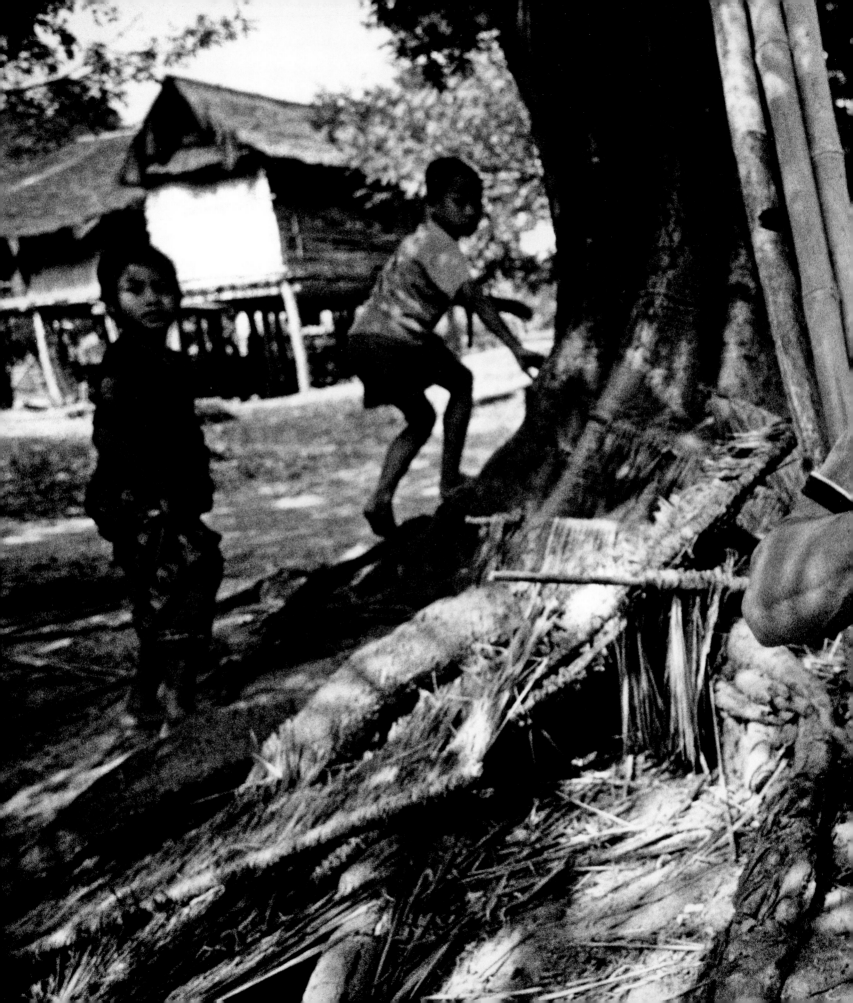

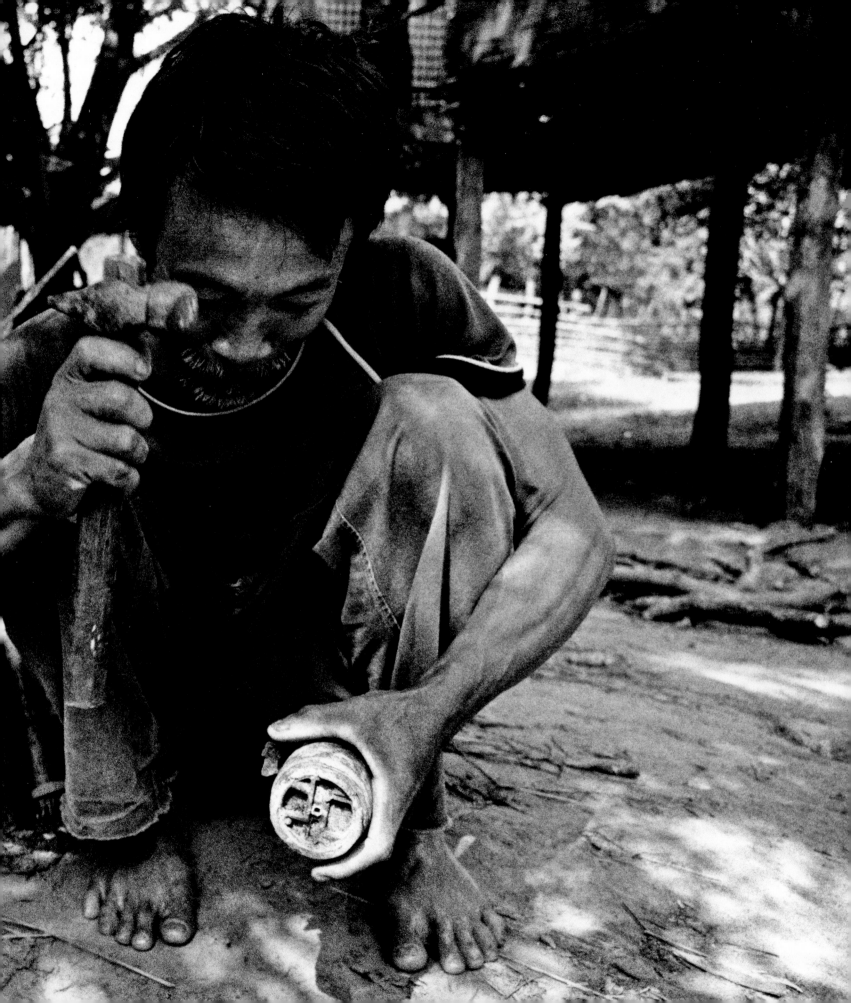

Previous pages: Fences and stilts made from cluster bomb units. Xieng Khouang Province.

Previous pages: Children back off as a villager tries to open a cluster bomblet to take out the explosives to make an oil lamp. This kind of activity claims lives almost daily in Lao PDR. Khammouane Province

This page: An oil lamp made from a cluster bomblet defused by a villager. Xieng Khouang Province.

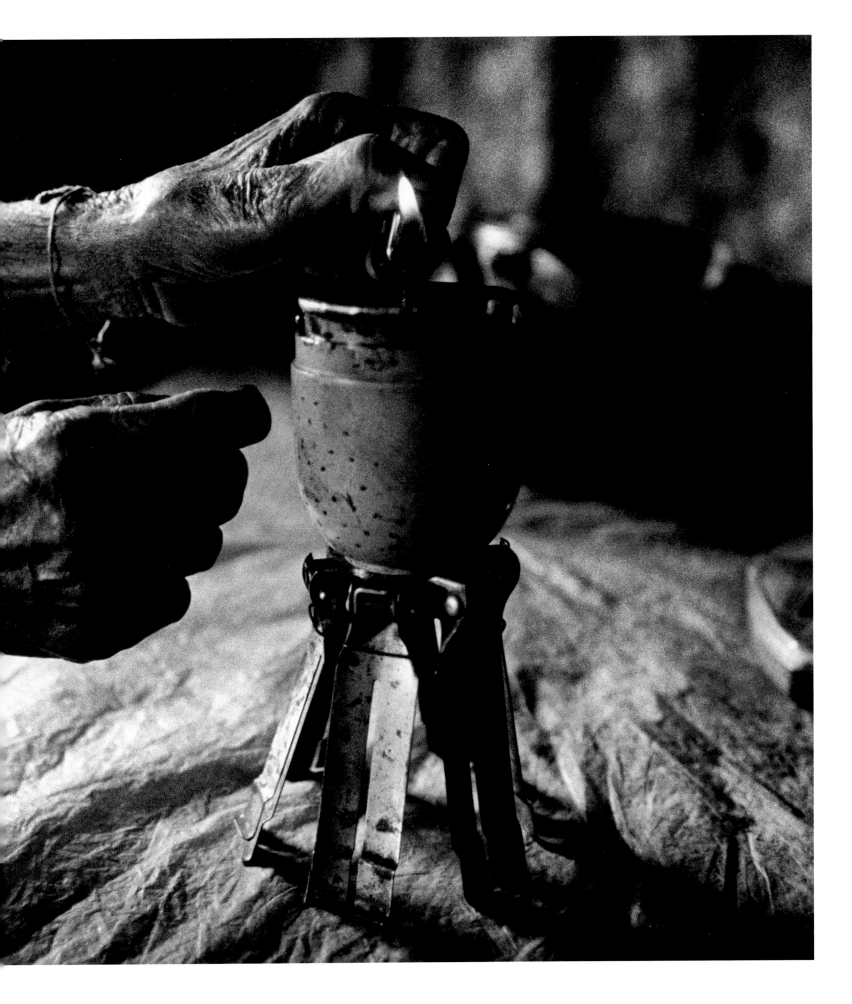

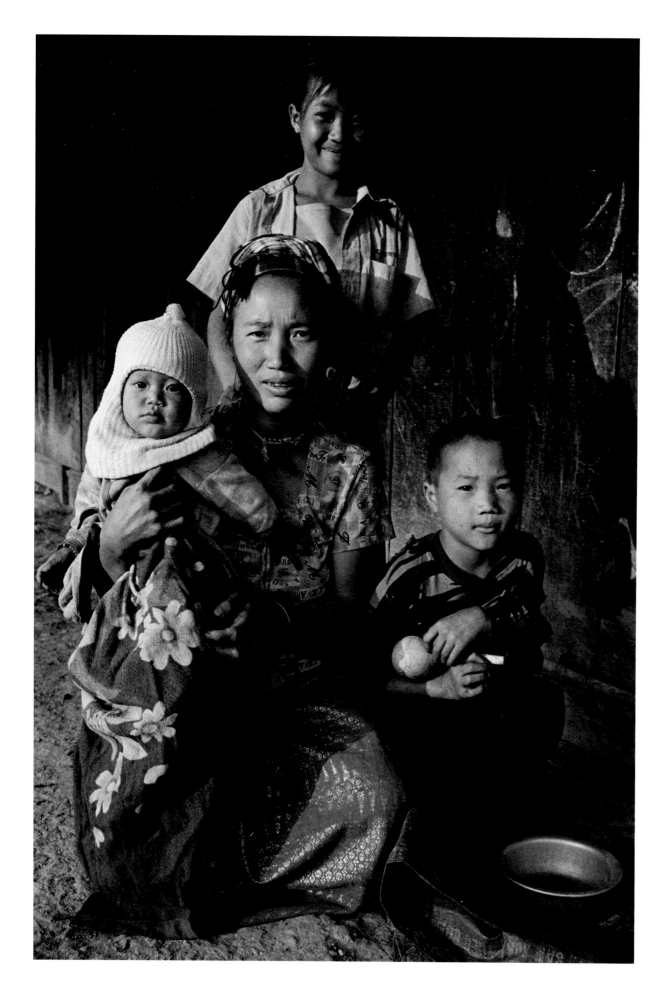

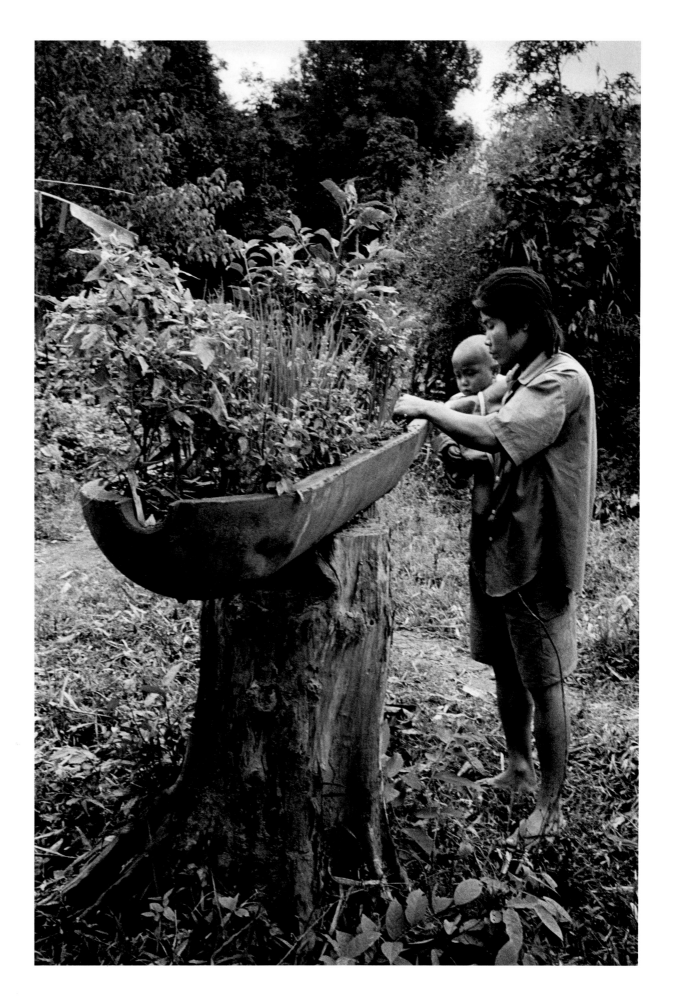

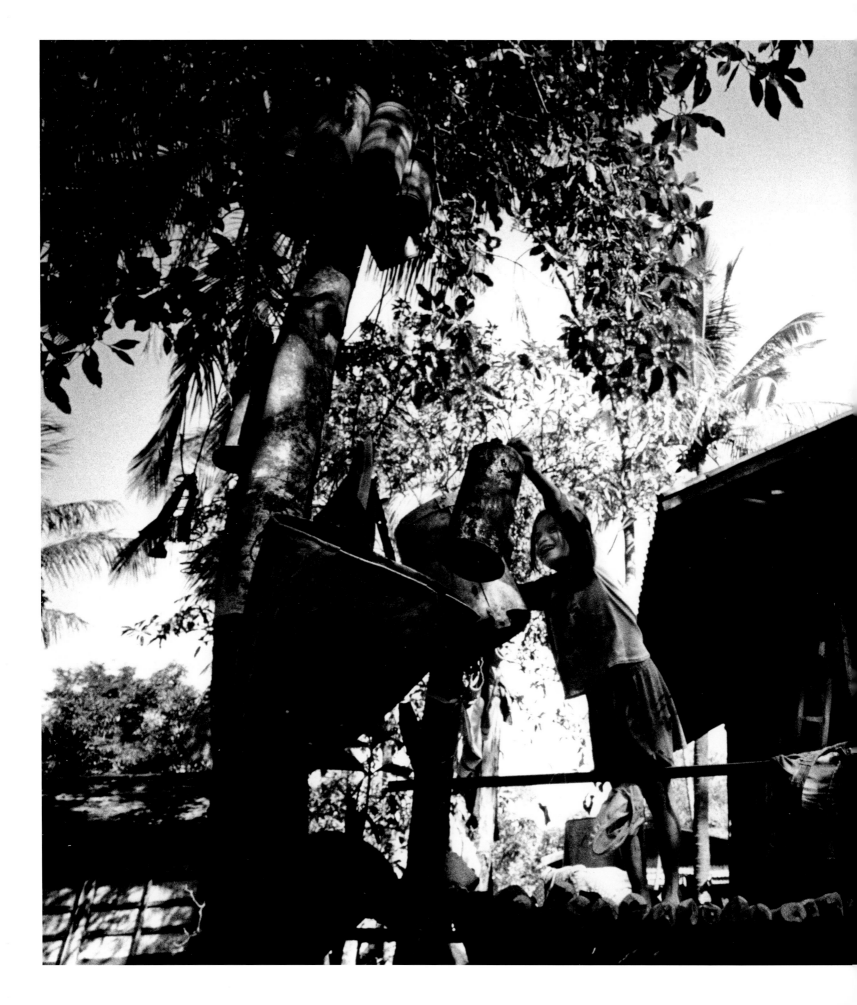

Previous pages, left:
Bi Family.
Khammouane Province.

Previous pages, right:
Thong weeds his vegetables
growing in part of a cluster
bomb unit with his son Nek.
Unexploded bomblets, dropped
in containers like this, are a
deadly legacy of the war. One
deadly bomblet lies less than
four metres from their house.
Ban Nong Boua,
Khammouane Province.

Left: In all households in the
village, the pots, pans, cutlery,
plates and bowls are fashioned
out of aircraft parts, rocket
casings, cluster bomb unit cases
and flare tubes. This photograph
shows numerous items made
out of the remnants of war. The
tubular containers in the tree,
made to ferment alcohol, are
made from flare tubes, a nose
from a cluster bomb unit is now
a bucket and rocket canisters
were used to make the
countless pots to the right.

Following pages:
A villager reaches for a
watering-can fashioned from
the nose of a cluster bomb unit.
Khammouane Province.

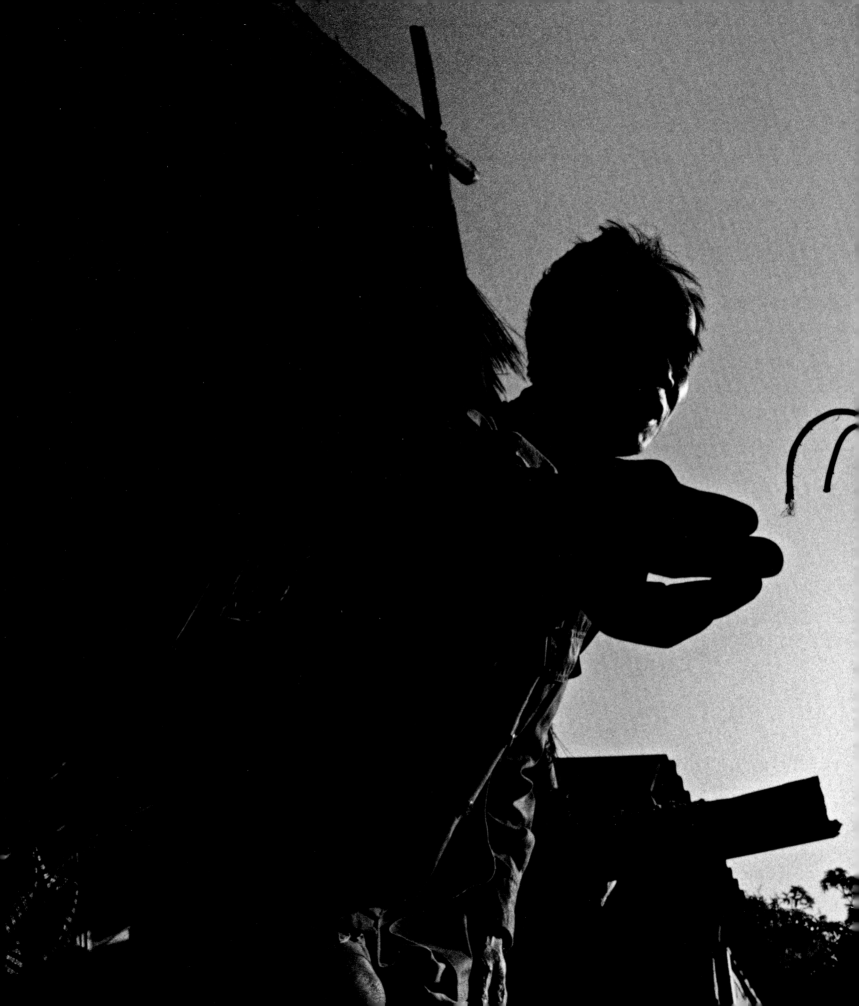

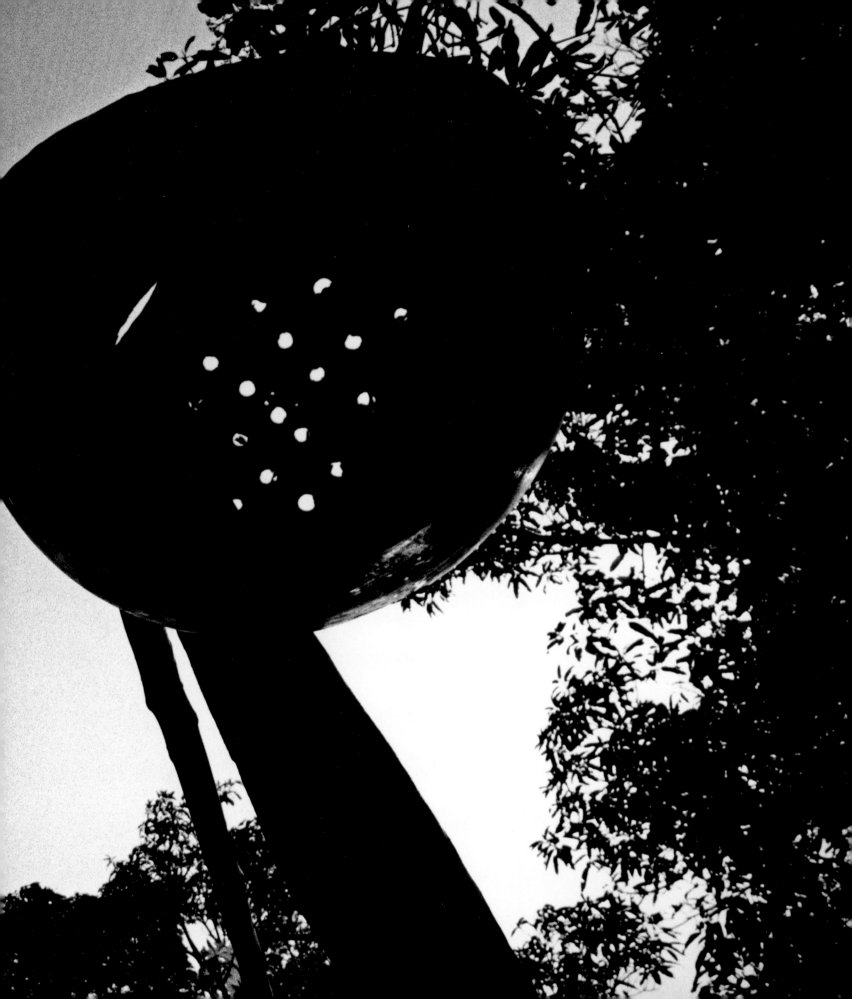

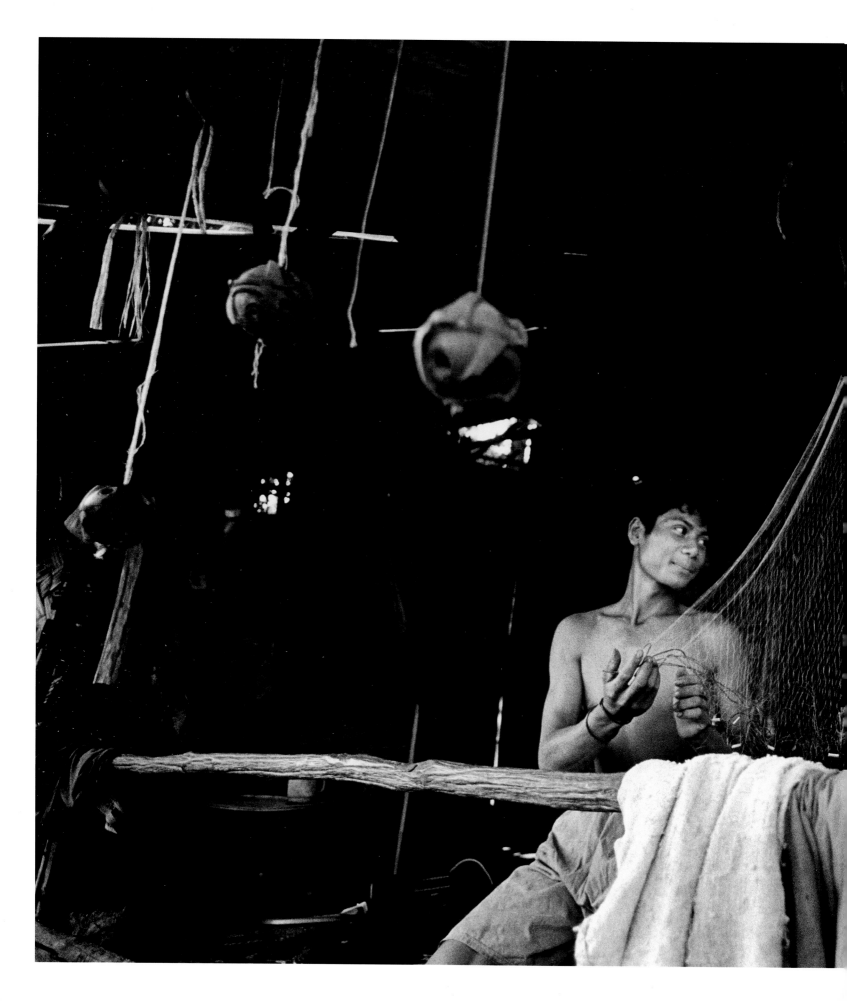

A fisherman mends his net in Phanop village. Like most villagers he also regularly collects scrap metal. He found these air-dropped mines and disarmed them. "I took them apart because we were told that they had gold inside. Now I hang them here because they look pretty." These scatterable mines have six spring-loaded tripwires that are expelled from the mine after it makes contact with the ground.

Following pages, top left: Somdy and her daughter Latsamy prepare sticky rice in their kitchen. All the pots, pans, cutlery, plates and bowls are fashioned out of aircraft parts, rocket casings, cluster bomb unit cases and flare tubes. In the background near the door is a bucket made from the nose of a cluster bomb unit.

Bottom left: Writing can still be seen on this cluster bomb water container. Khammouane Province.

Right: A shop selling, amongst other things, old American helmets, defused cluster bomblets, batteries and Buddha statues. Xieng Khouang Province.

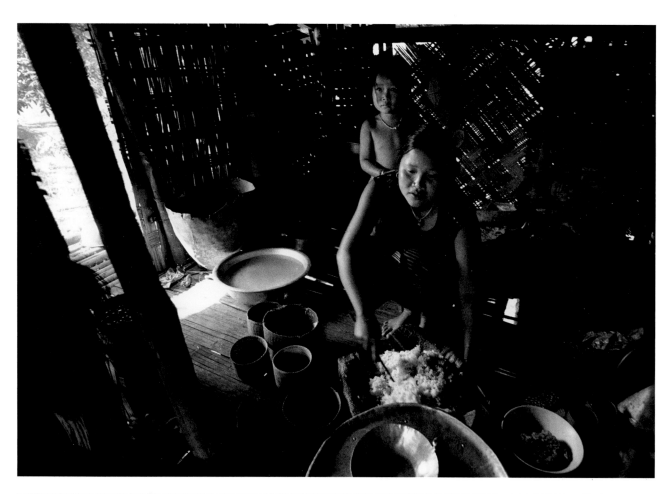

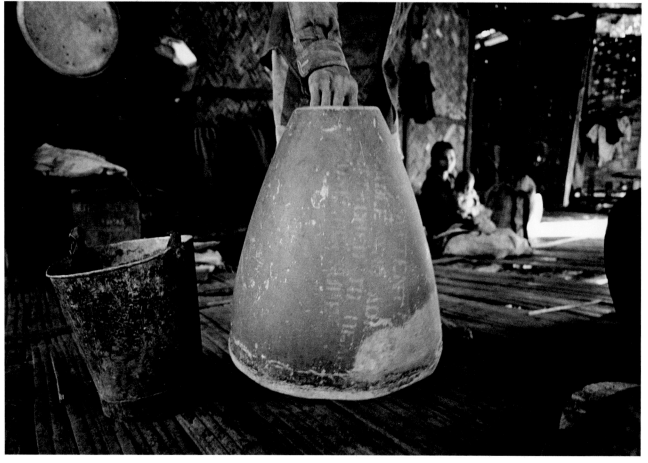

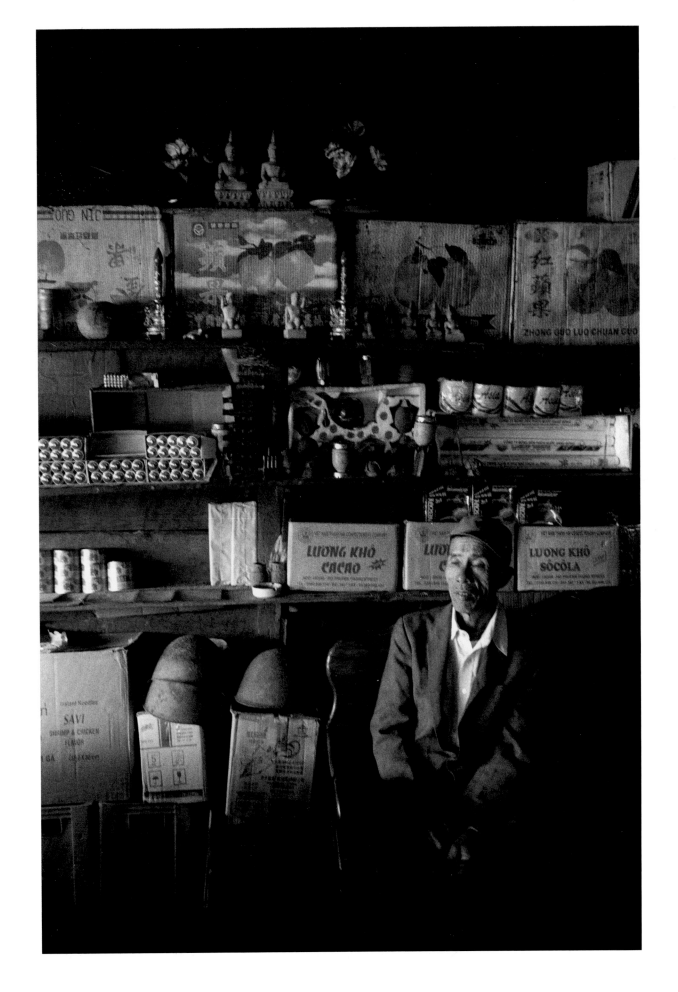

Mr Sopha hammering out the
blade of a sickle. His anvil is
the base of an artillery shell
and the photograph is framed
by one of the fragmentation-
damaged cluster bomb casings
that support the roof of his forge.
Xieng Khouang Province.

Following pages:
Boats fashioned from discarded
fuel tanks from American fighter-
bombers. Savannakhet Province.

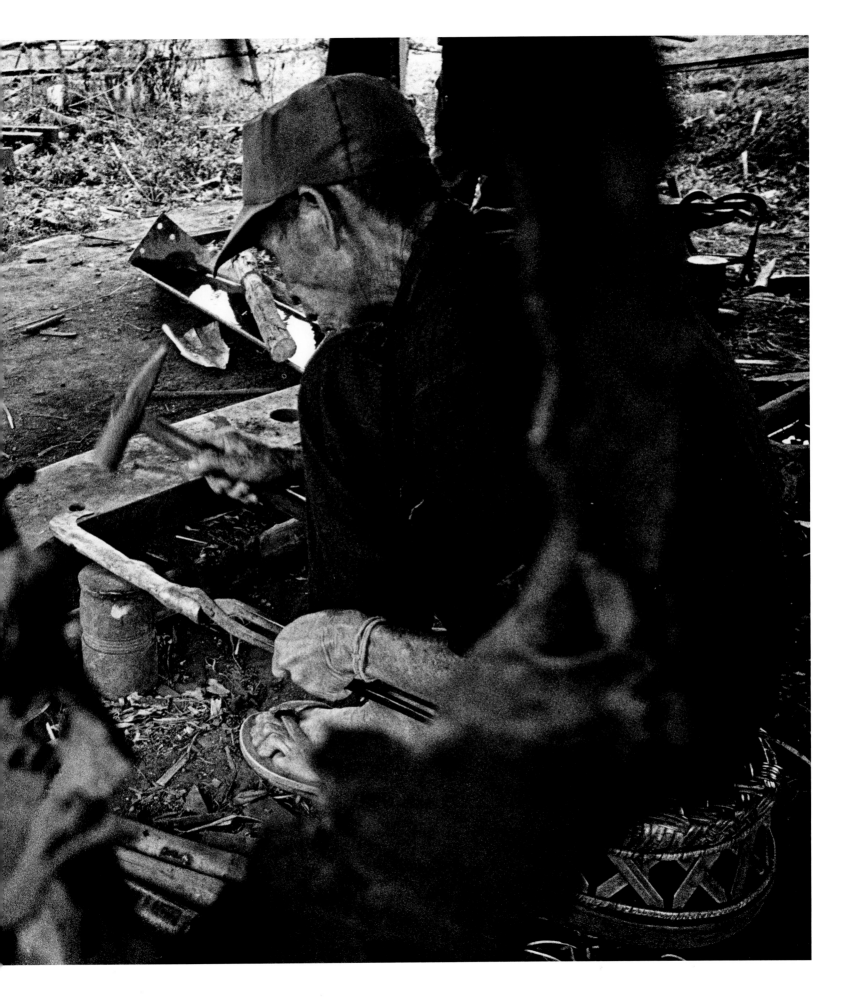

Previous pages, right:
Mortar bombs help to hold
down the thatched roof
during storms.
Savannakhet Province.

This page, right:
Eight-year-old Chan and his
grandfather Pack, tamper
with munitions. Chan has a
40mm grenade, a particularly
sensitive munition.
Xieng Khouang Province.

Following pages:
Children with a cache of
projectiles they have found
on a riverbank.
Khammouane Province.

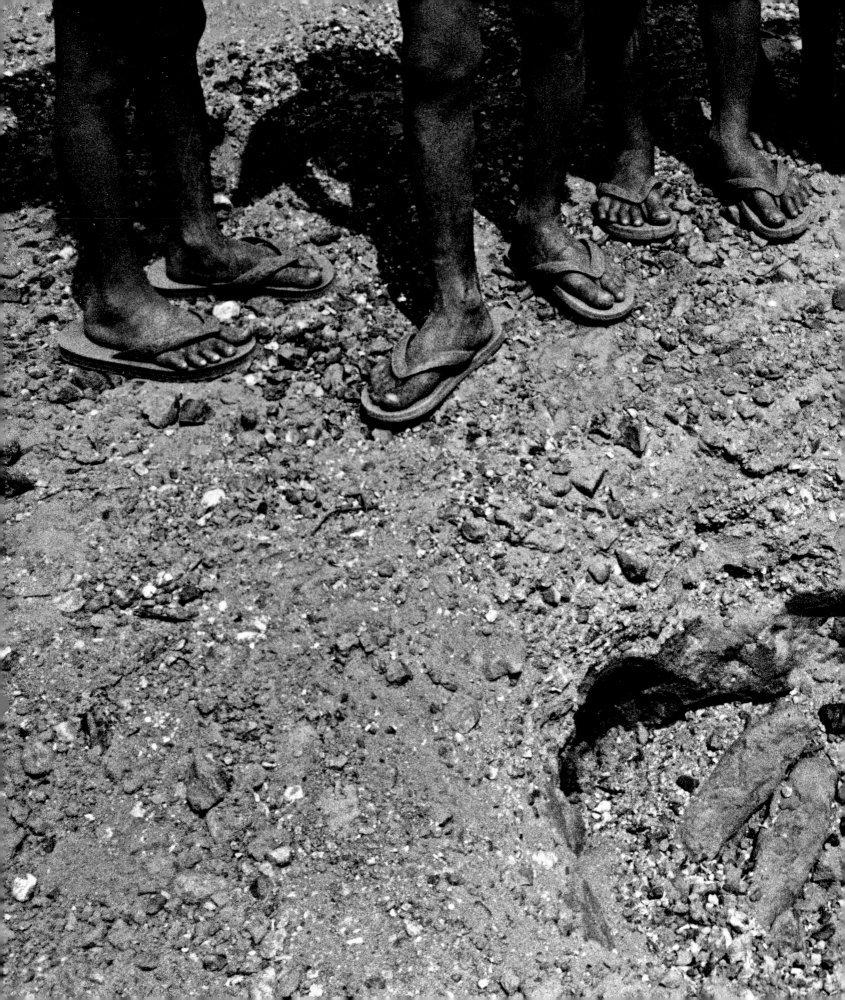

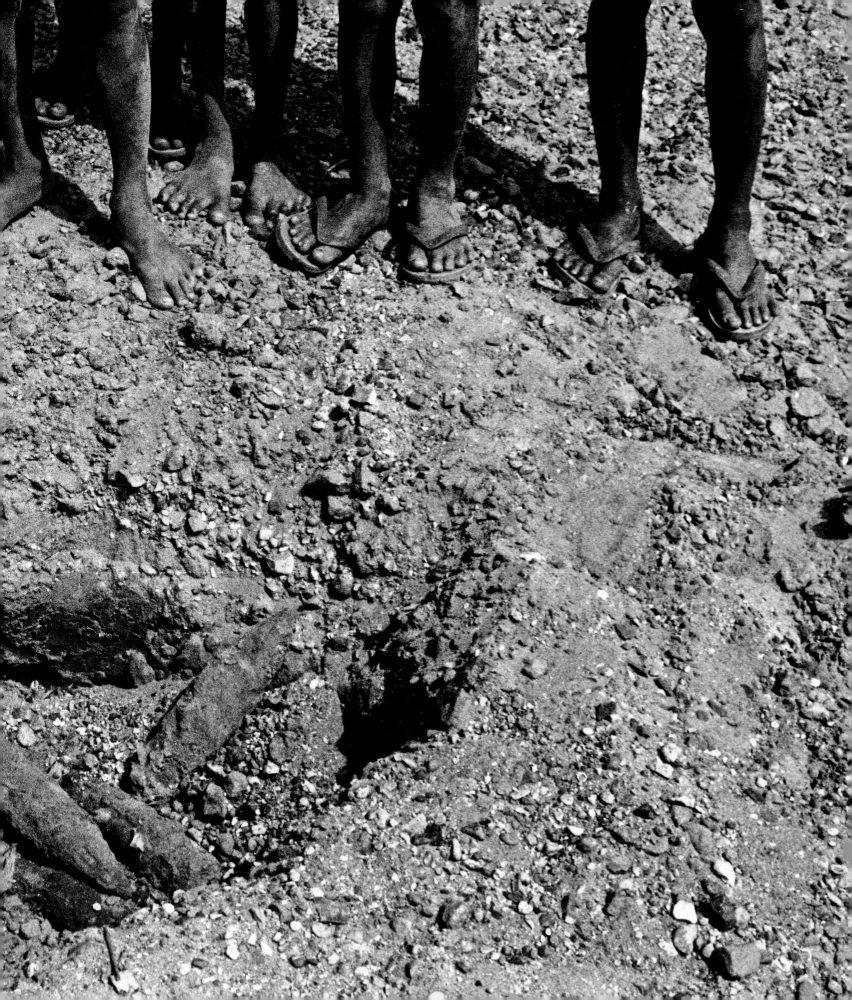

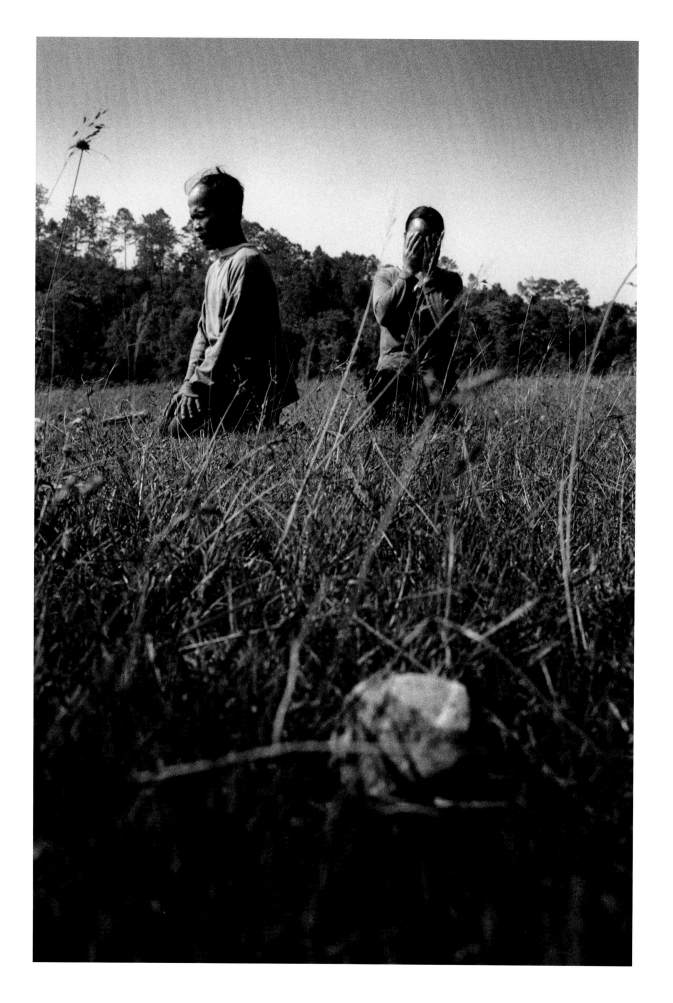

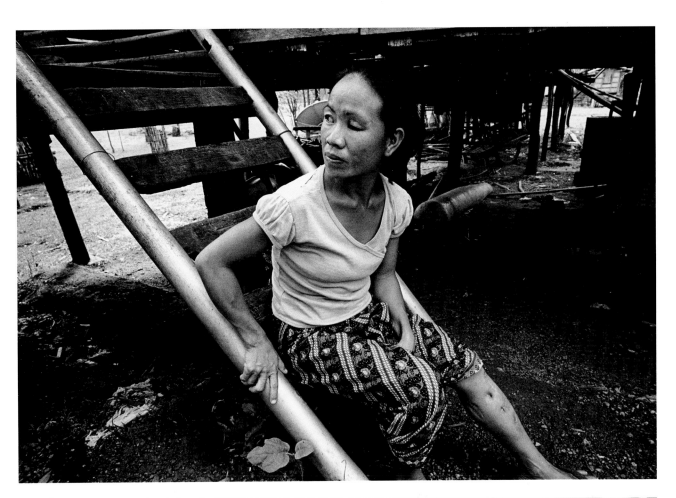

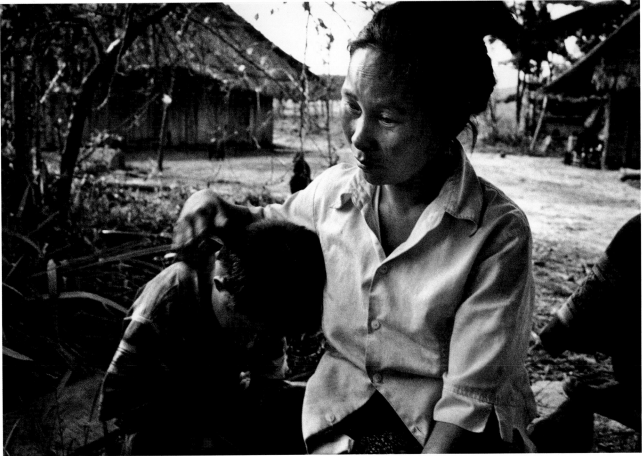

Previous pages, left: Mother and father grieve at the spot where their son was killed with a friend a week before. They were playing with cluster bomblets, one can be seen in the foreground.

Top right: Twenty-five-year-old Mrs Air was working in a rice paddy when she stopped work and prepared a fire to make lunch for herself and family members. "I lit the fire and a few minutes later it exploded." Khammouane Province.

Bottom right: Mrs Paya lost four children and her husband in an unexploded ordnance accident. "It was in the late afternoon. We were all outside. My husband was chopping wood with the children. His axe hit something under the ground and there was an explosion. I was sitting with my baby, not far away. I was hit with shrapnel. So was my baby. She was killed. I have lost everyone and everything except one son." Mrs Paya and her husband had chopped wood in the same place by their house many times before. A neighbour's two children were also killed. Xieng Khouang Province.

Left: People drink home-made alcohol during the ceremony to bless Noukarn's spirit. He was killed three months earlier when he set off an explosive device whilst looking for scrap metal, a risky activity that is common in Lao PDR.

Above: His twenty-three-year-old wife takes part in the ceremony. Khammouane Province.

High-risk trade

It's about nine o'clock in the morning. Villagers searching for scrap metal on a valley floor deep in the jungle hear a huge explosion. The sound reverberates around the towering mountains. Someone has been unlucky today.

With development indicators amongst the lowest in Southeast Asia, the people of Lao PDR face serious challenges of poverty and food security, problems especially acute amongst the subsistence farming communities that form the bulk of the population. Unexploded ordnance is an ongoing threat in many provinces and an obstacle to development.

In many areas the scrap trade has been a major source of income for communities since the war ended more than 30 years ago. The trading of war scrap takes place in many countries after conflict, but what singles Lao PDR out is the amount of metal around – more than two million tons of ordnance was dropped during the sixties and seventies.

People have become reliant on the scrap trade and although it is officially illegal whole communities – including children – search the ground. They use primitive $10 Vietnamese metal detectors and small shovels to check the paddy fields and jungles. Those who are older and more experienced recognise the majority of the dangerous items and will leave them where they found them – especially the round, orange sized cluster bombs. But many of the younger people do not know the difference.

People say that they have no choice but to look for scrap metal. "We don't grow enough rice," said Kham in Phanop village. "Our land has flooded a lot in recent years so the harvests have been very bad. We grow only 20 per cent of the rice we need. I know collecting scrap metal is dangerous, but my family must do it to live."

In the past all the metal collected went to smelters in Vietnam but now factories have been built in Laos. It is very organised. The scrap collectors get $1.70 for a kilo of copper, $0.82 for a kilo of aluminium and about $0.35 for a kilo of explosives. On average they find about seven kilos of metal a day.

Villagers have developed their own way to 'low-order' a large bomb. This is a technique to blow the bomb apart without a significant explosion or 'high-order'. This is so that they can retrieve the iron from the bomb for its scrap value. They place a cluster bomb, or bomblet, on some dry wood next to the bomb, light a fire and retreat.

People are now trying to knock the fuses off shells and large bombs. Outside one of the scrap merchants in Lang Khan Junction, in Khammouane province, there are hundreds of sacks full of explosives and

dozens of empty bomb casings. And people are dying. No one knows how many have died. The deaths are often not reported.

Back in the valley and blinded by the blast in the jungle, twenty-five-year-old Leng crawled out to the roadside. He had managed to find his way up the mountainside through five kilometres of trees and undergrowth. His two friends did not make it. Fifteen-year-old Ten and thirty-year-old Talay were killed in the explosion. They were trying to chisel out the tail fuse on a 250lb bomb. Talay had quite a reputation as an expert at this. Villagers said he had done it successfully dozens of times. He only needed to do four more and he would have had enough money to pay for his wedding, planned for the following month.

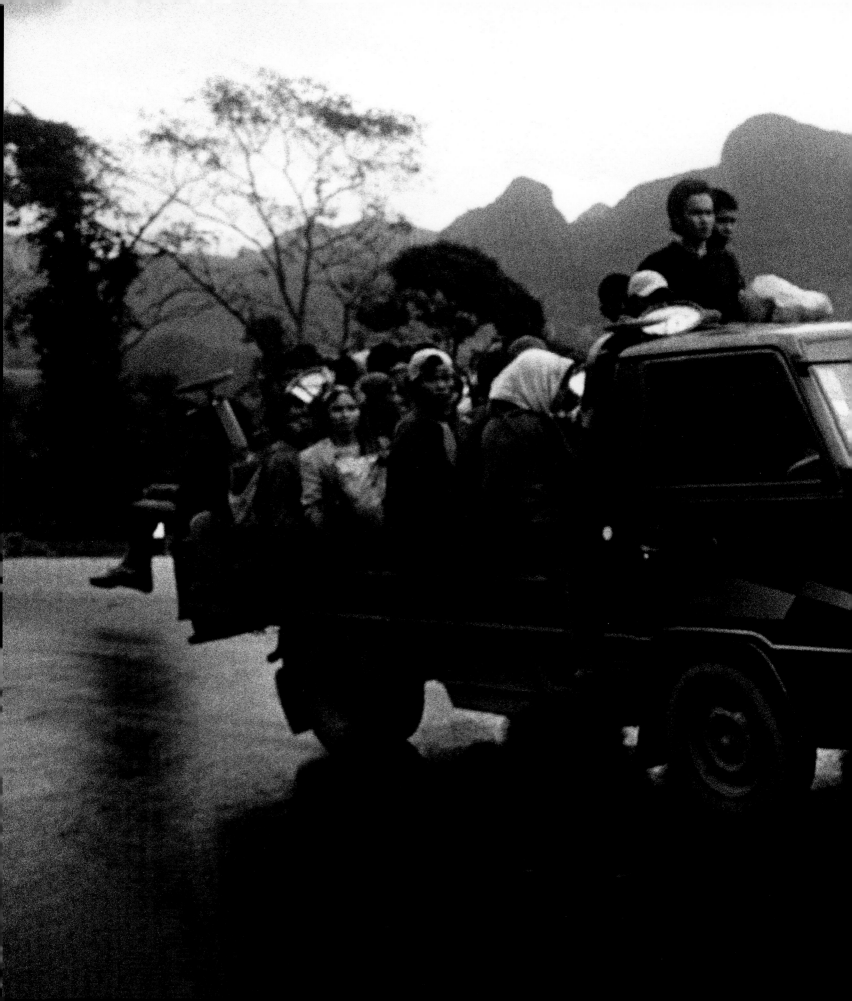

Previous pages: A dealer's truck takes scrap collectors home to their villages. Khammouane Province.

Right: Villagers on their way to work collecting scrap. They say that they don't grow enough food to survive and that they have no choice but to do this dangerous work.

Following pages: Scrap collectors climb from the valley floor up to the roadside with their finds. This man has found a mortar bomb still full of explosives. This area is close to the Vietnamese border and was part of the maze of tracks and paths known as the Ho Chi Minh Trail. Khammouane Province.

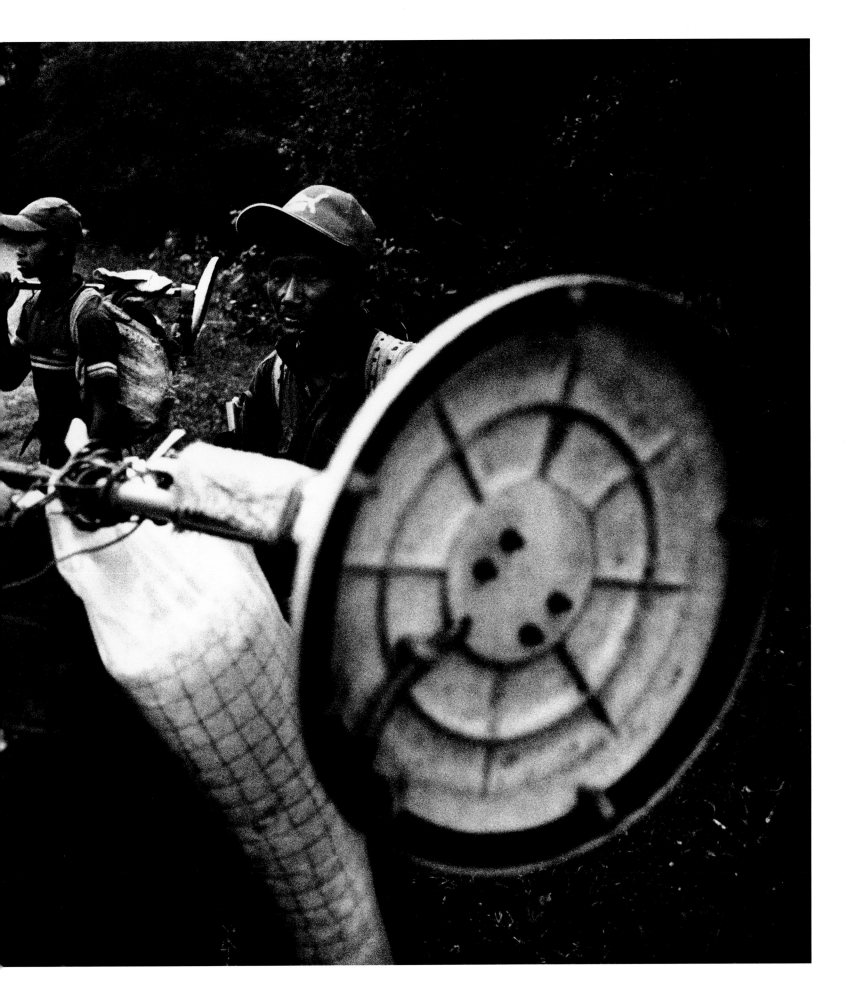

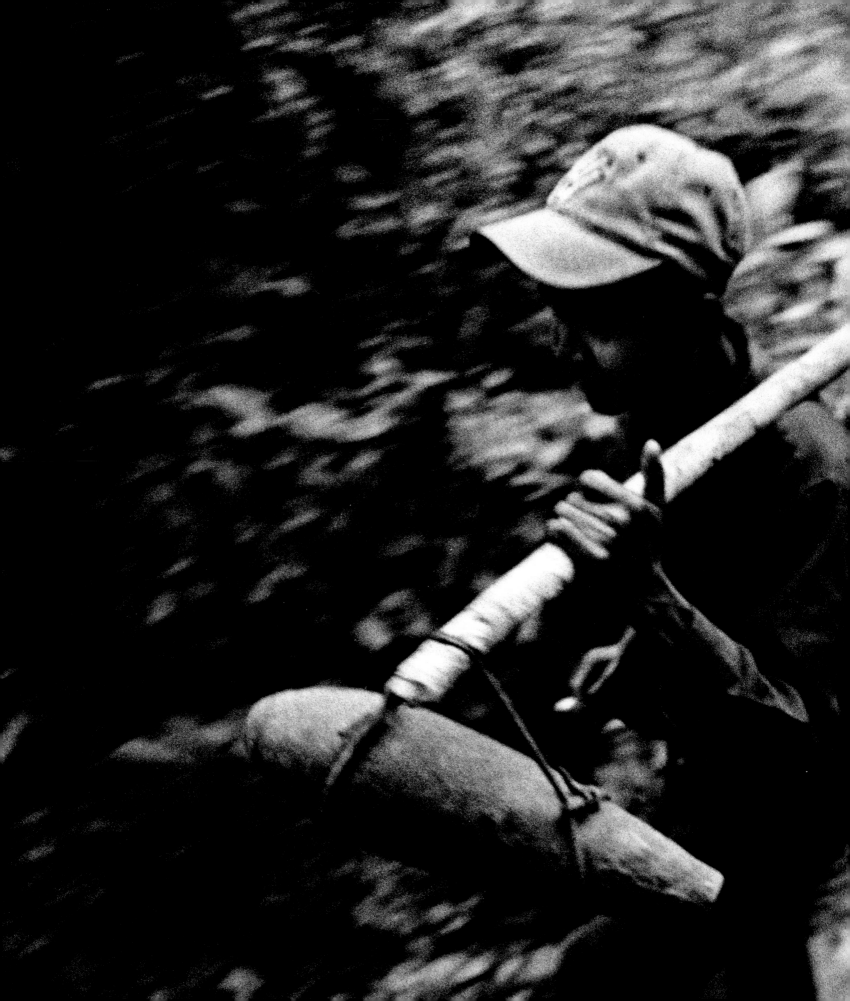

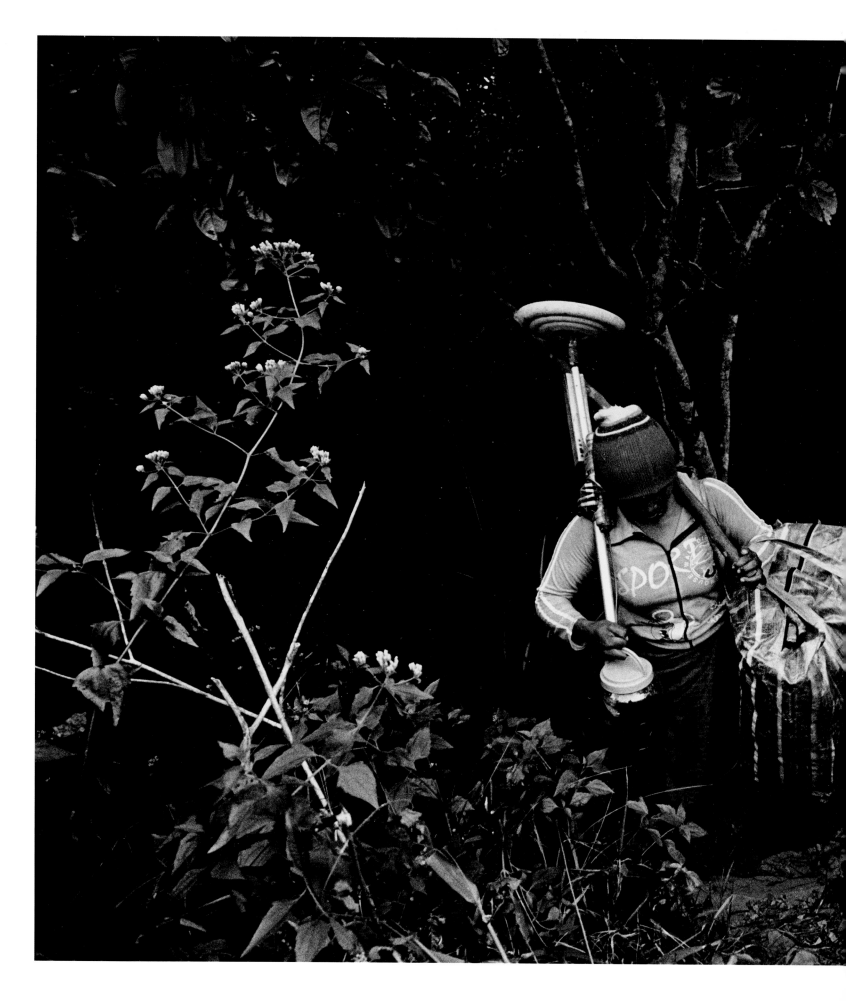

A woman climbs out of the
jungle after a long day's work,
with her bedding and a jar full
of fish she caught in a stream.
Khammouane Province.

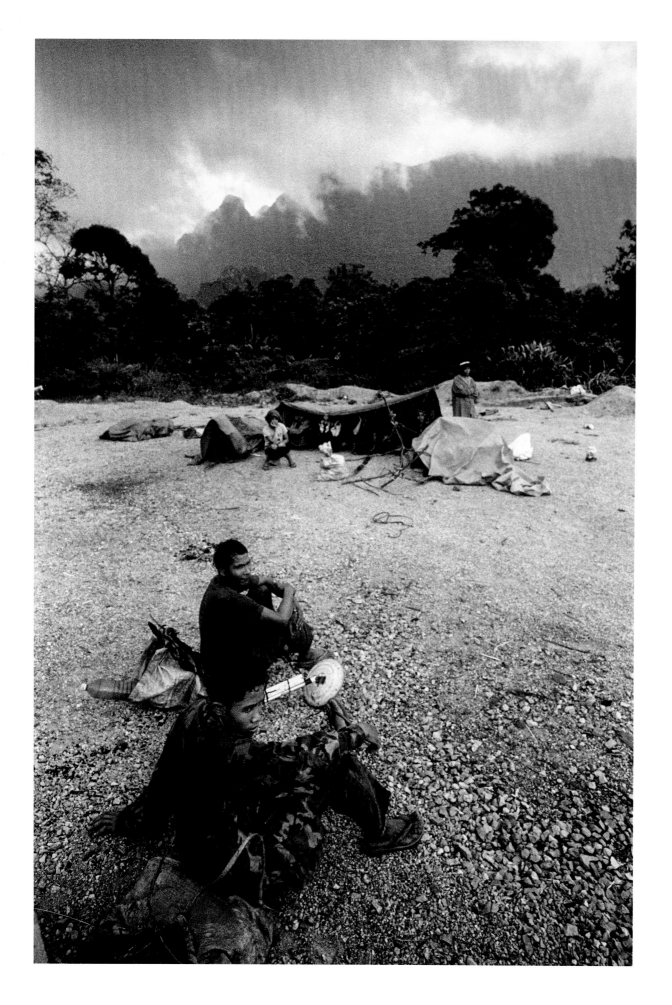

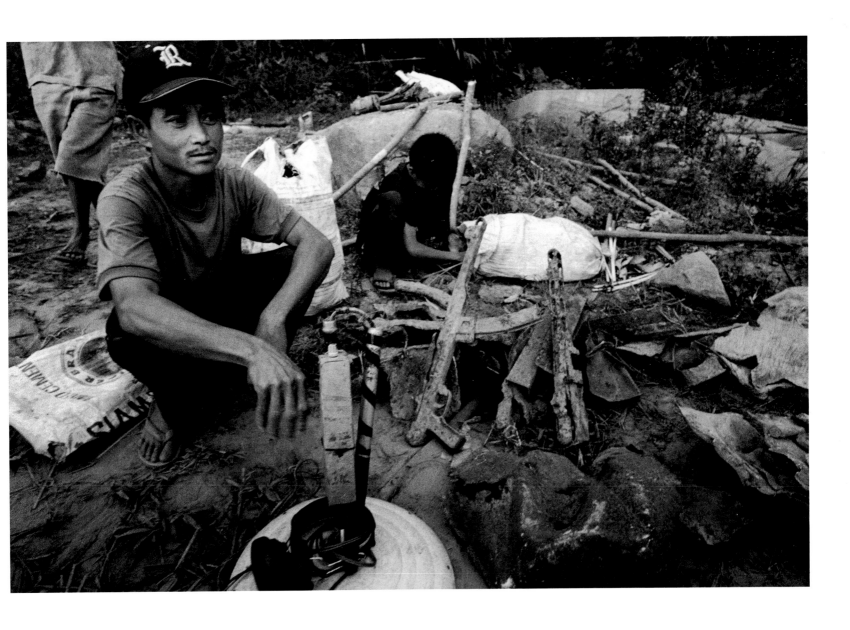

Above: Scrap collectors wait for buyers by the roadside with their finds. Khammouane Province.

Left: People camp for up to a week at a time by the side of the road close to the Vietnamese border. This was one of the passes used by Vietnamese forces and was relentlessly bombed. Consequently, there is a lot of scrap metal to be found here.

Following pages: Eighteen-year-old Chai and her twelve-year-old brother Song look for scrap metal. They go up to the mountains for up to a week, living on rice they bring with them and bamboo shoots and roots they find in the forest. They spend the day searching and digging and bring their finds to the roadside. Traders in trucks and pickups collect the scrap from them daily. "We can make money for our family doing this and there is no other way for us to make money," explained Chai. "I know it can be dangerous and people in the village have been killed, but we are careful." Khammouane Province.

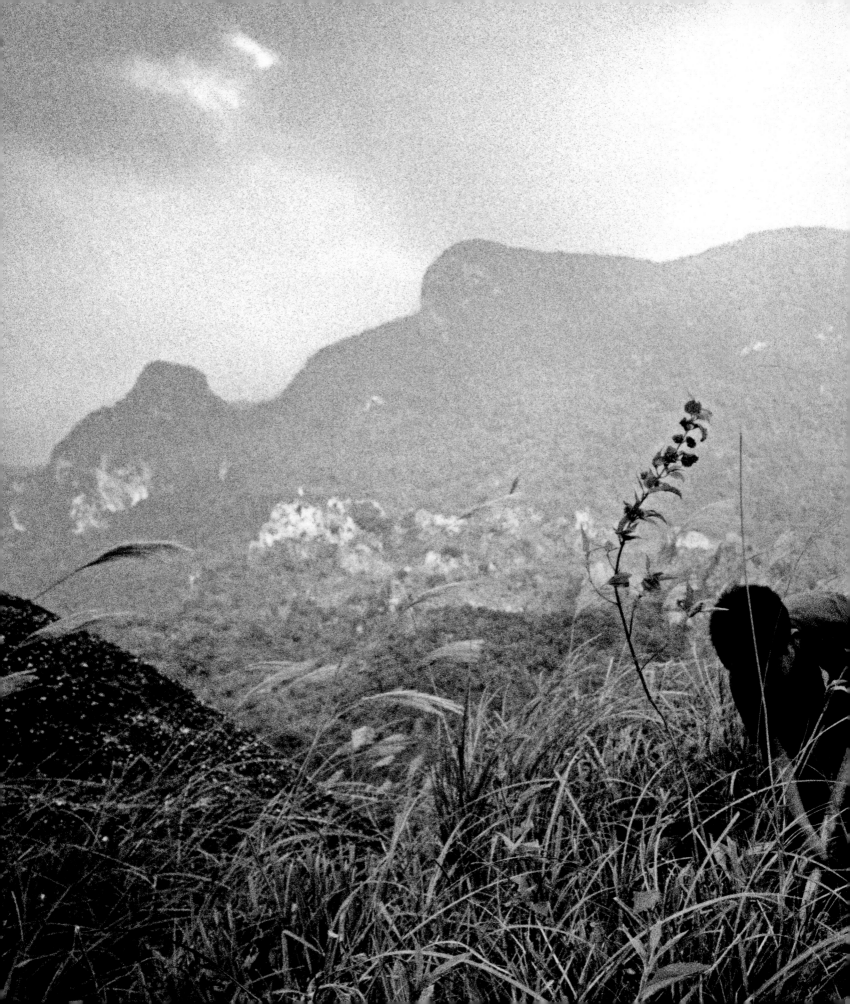

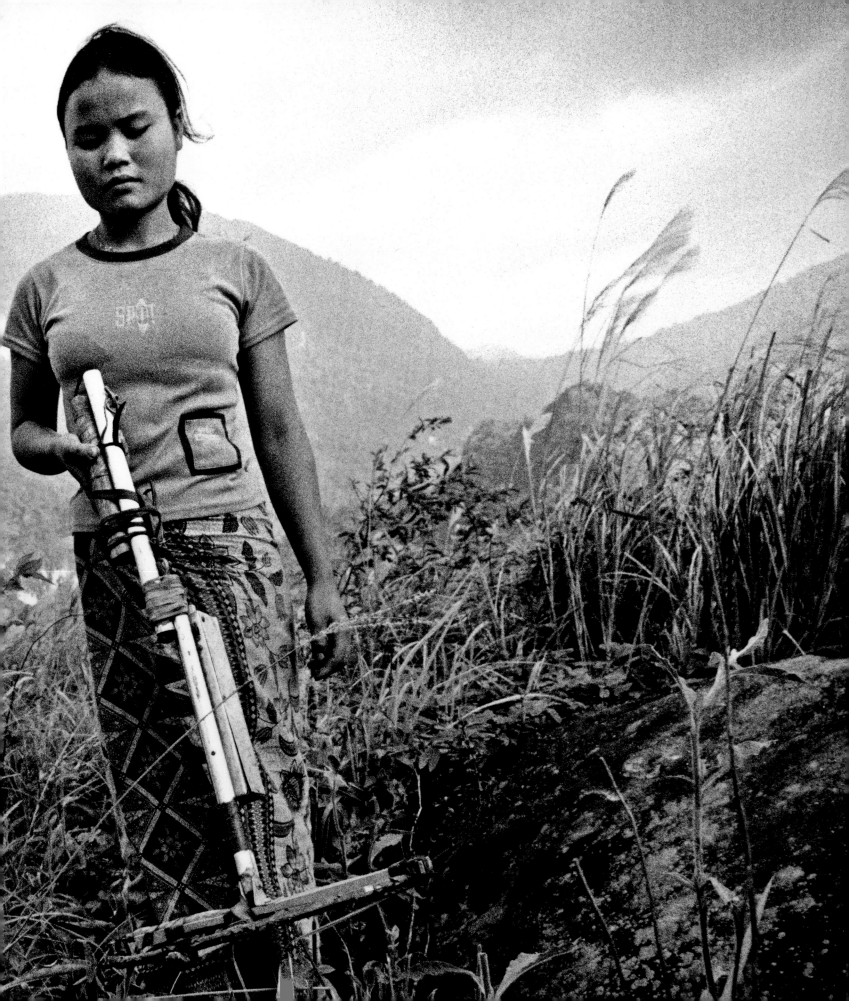

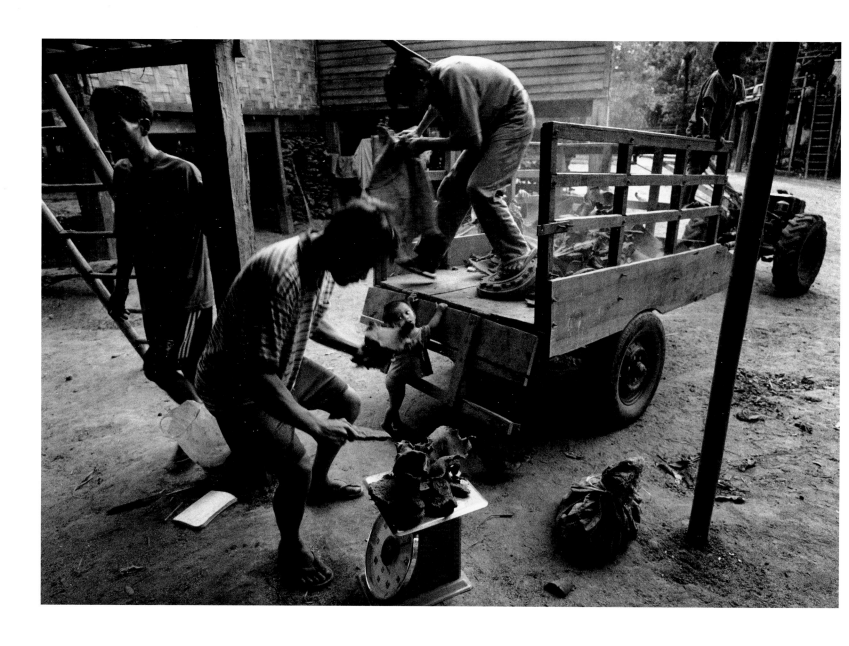

Scrap metal found by villagers is weighed by a dealer.
Khammouane Province.

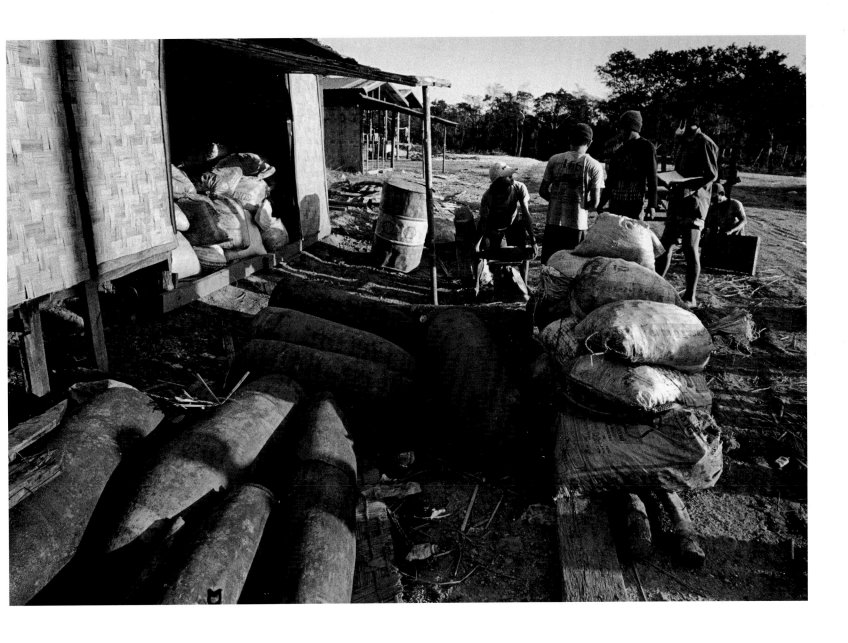

People hand in shells and large bombs to a scrap dealer. The large sacks inside and outside the building are full of explosives. Local people defuse the bombs at great risk and many are killed. A large bomb is worth approximately $50. The recent market for explosives in this area has increased the risks people take. Khammouane Province.

Villagers have just defused
a number of bomblets they
found earlier. They are
still full of explosives.
Khammouane Province.

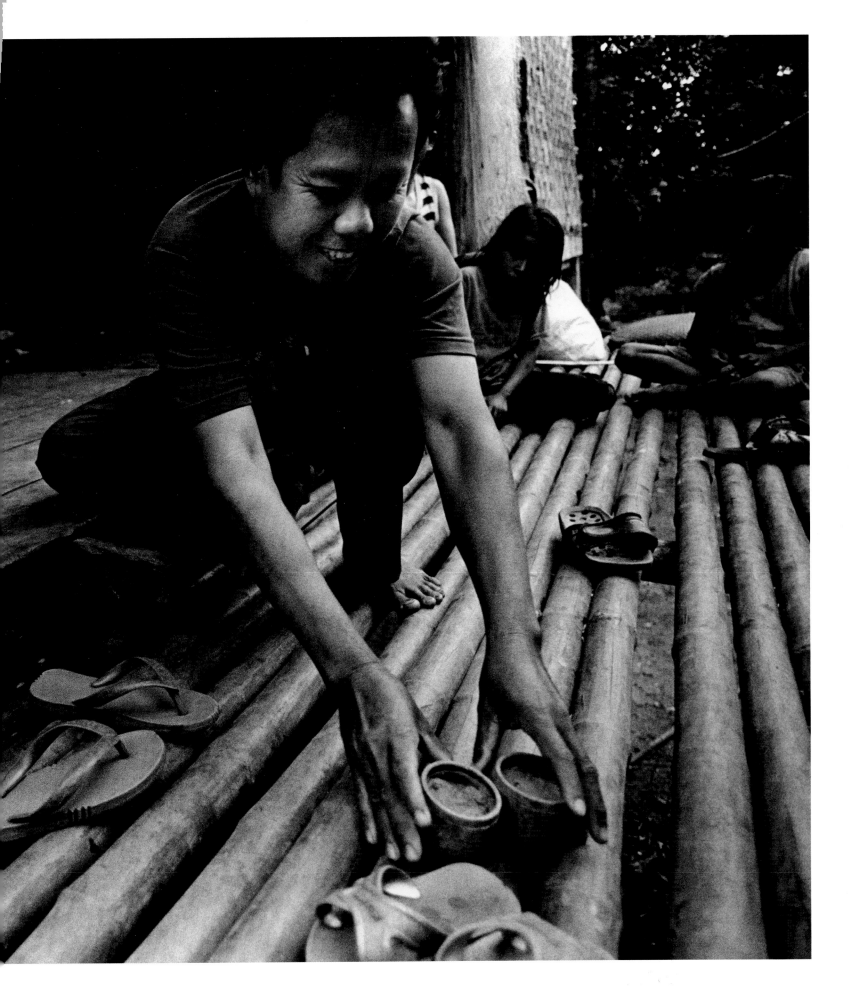

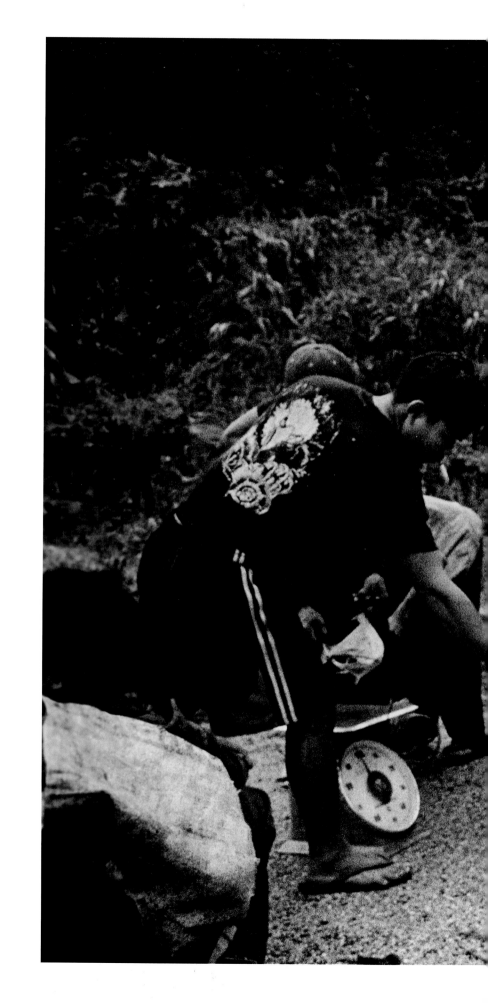

Scrap dealers arrive late in
the day to take people back to
their villages and to weigh
and buy the scrap metal.
Khammouane Province.

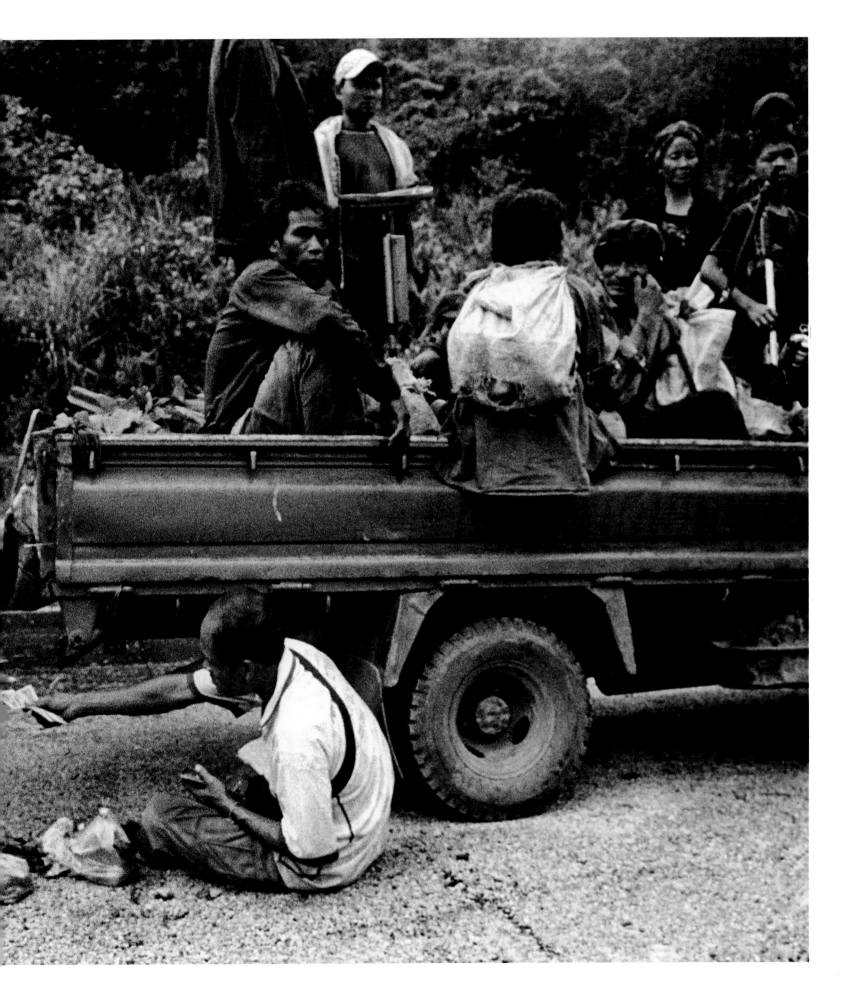

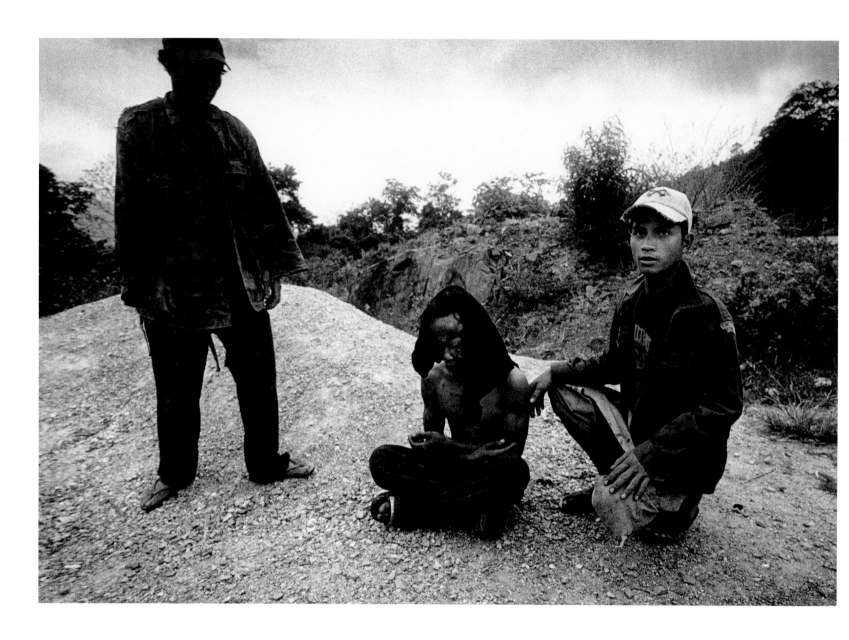

The survivor: Twenty-five-year-old Leng managed to find his
way back up to the road by himself through five kilometres
of jungle, following an explosion that left him blinded. He
had been with two colleagues from his village. "Talay and
Ten were trying to get the fuse off a large bomb and it blew
up. I was a bit further away so I am alive. Ten told me he was
going to die and that I should try and get back here if I can.
Talay didn't say anything. I think he was already dead."
Khammouane Province.

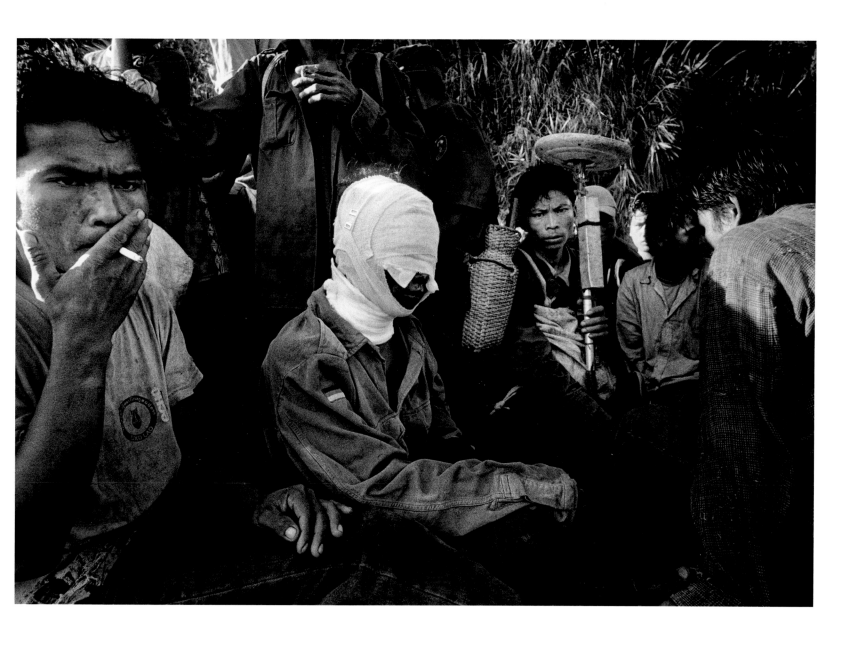

Leng waits for the scrap dealer's truck to take him home. People must be wondering whether anyone else is still alive from the accident. Talay is from Najat village. In the last year there have been seven deaths from his village alone. Collecting scrap is a dangerous occupation. Khammouane Province.

Following pages, left: The body of seventeen-year-old Ten.

Following pages, right: Van mourns the death of her brother Talay close to his body in the jungle. Khammouane Province.

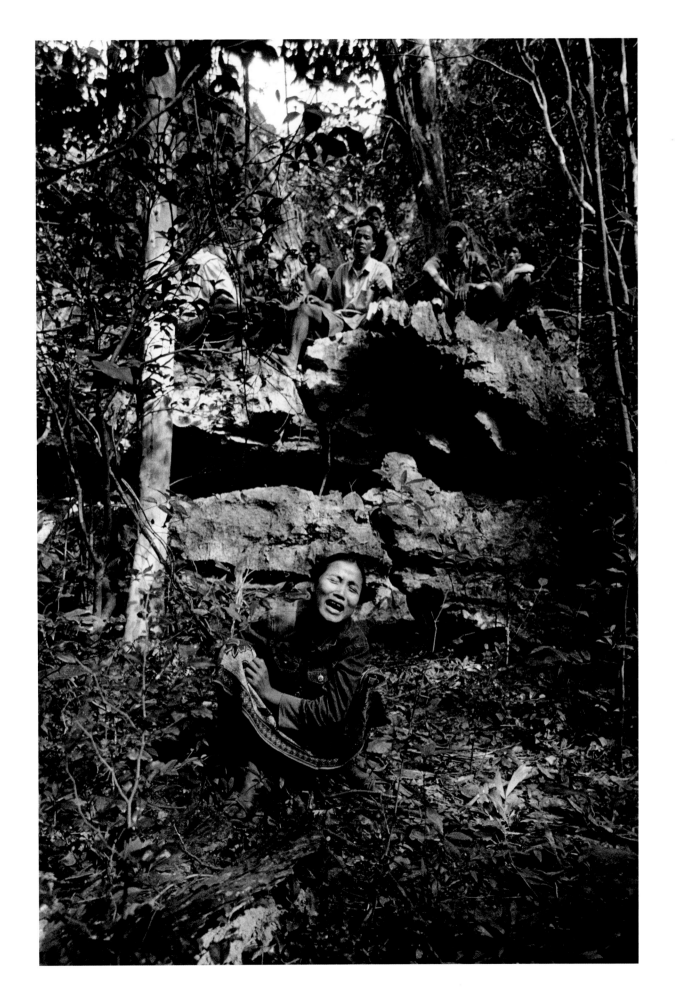

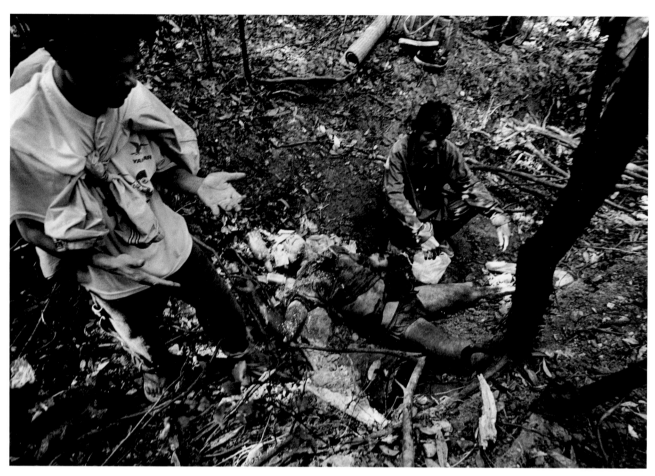

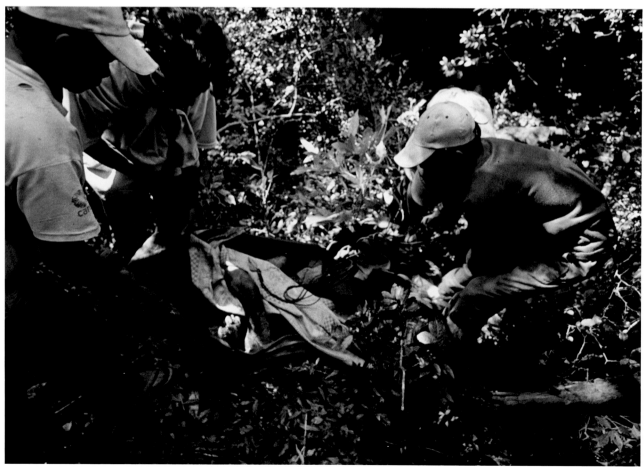

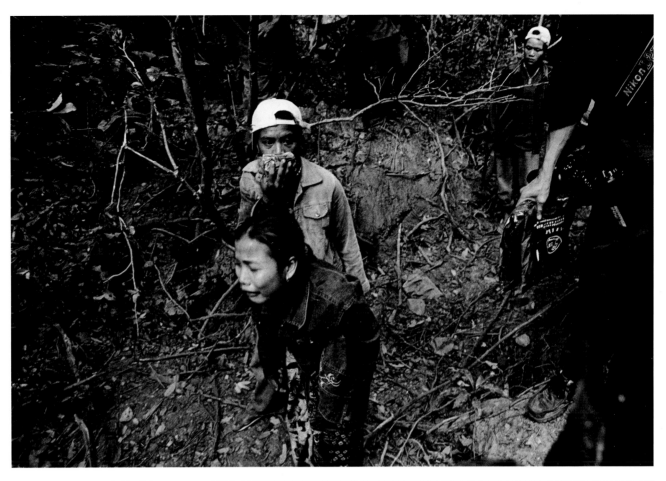

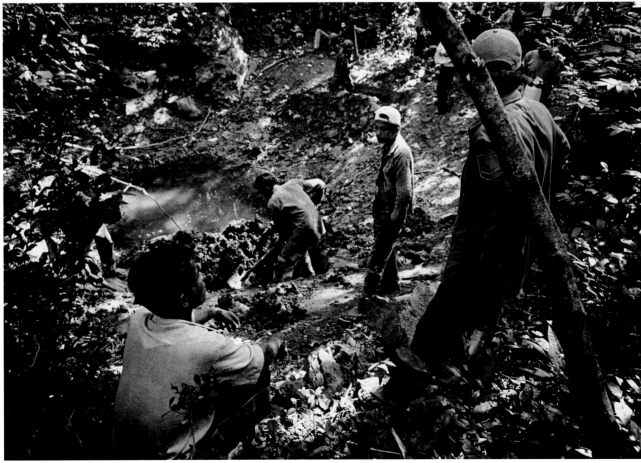

Previous pages, top left:
The remains of thirty-year-old
Talay. Many people from Najat
village have come to mourn and
bury their dead.

Top right: The moment Van sees
the remains of her brother Talay.

Bottom left: Seventeen-year-old
Ten's body is carried to his grave.

Bottom right: Villagers dig
graves in the sides of a large
bomb crater. In keeping with their
Animist religion, the dead are
buried with food, money and
belongings including their metal-
detectors. Khammouane Province.

This page, right: Ten's grieving
family the day after the accident.
The tragedy doesn't seem to have
sunk in yet with his young sisters.
Khammouane Province.

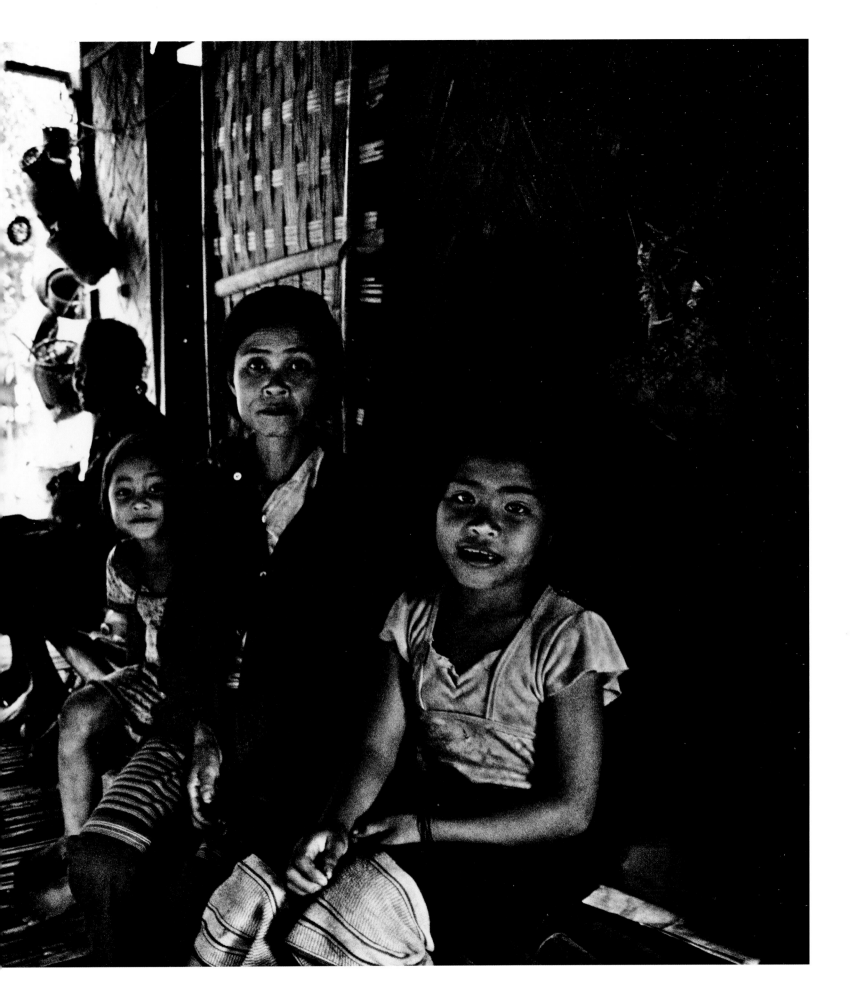

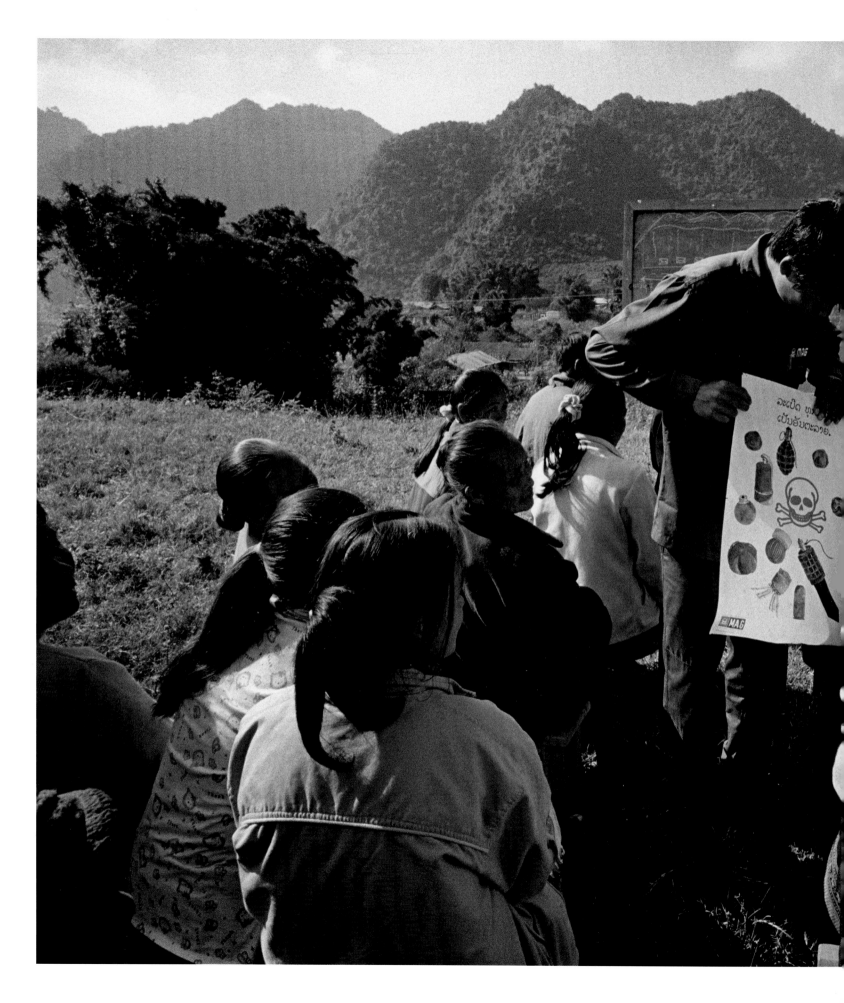

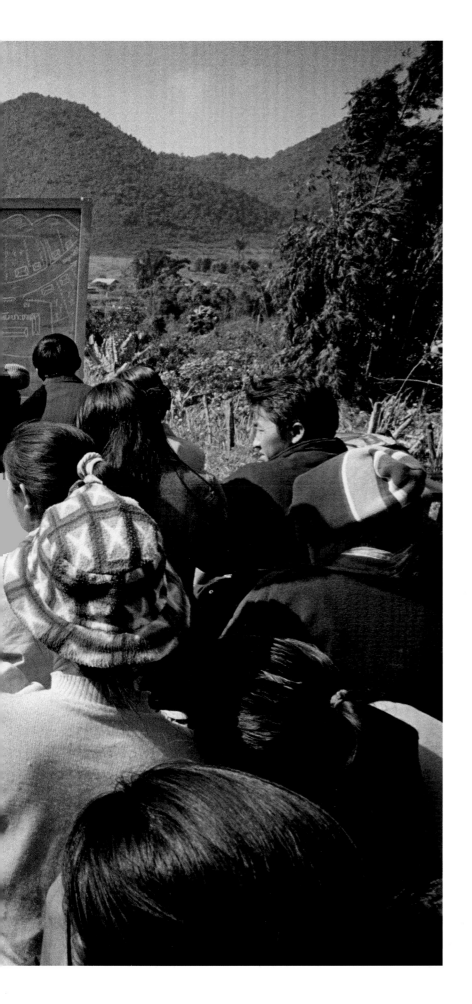

Community Liaison session. The MAG team discusses the priorities for clearance determined by the community. Amongst other things, this involves drawing a community map, explaining MAG's methodologies and unexploded ordnance awareness discussions. Xieng Khouang Province.

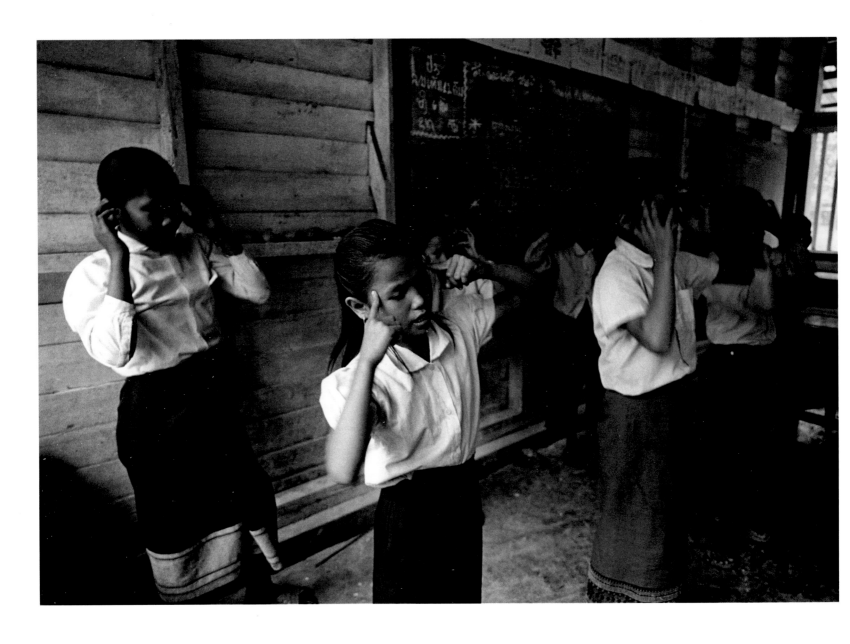

As part of an unexploded ordnance awareness lesson, children
sing and dance to a song about cluster bombs called 'Don't touch'.
Khammouane Province

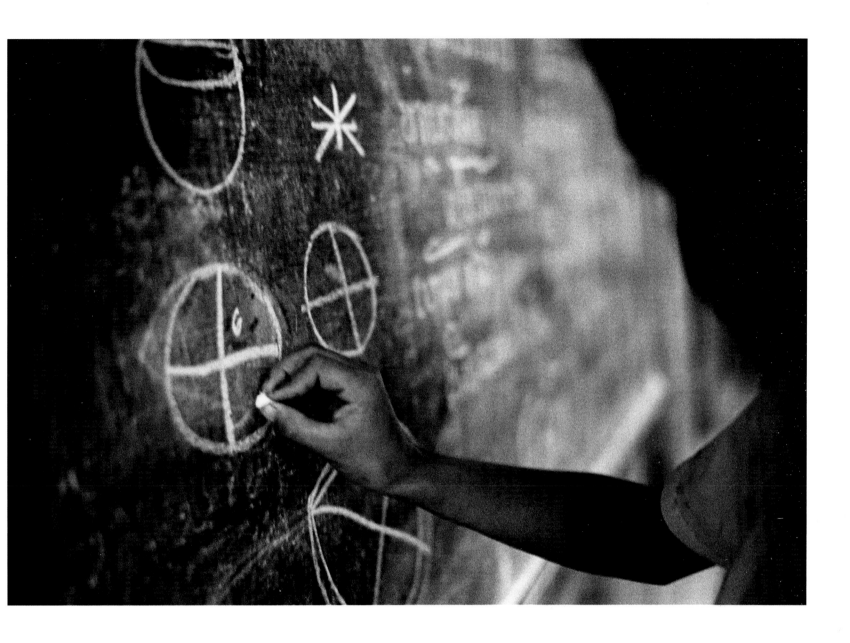

Children draw pictures of the deadly bomblets
from cluster bombs that still litter their
playgrounds 30 years after the war ended.
Khammouane Province.

Following pages: A villager shows Community Liaison
staff unexploded bomblets in Nong Boua village.
A report with a map and GPS coordinates will
be given to one of the technical teams.
Khammouane Province.

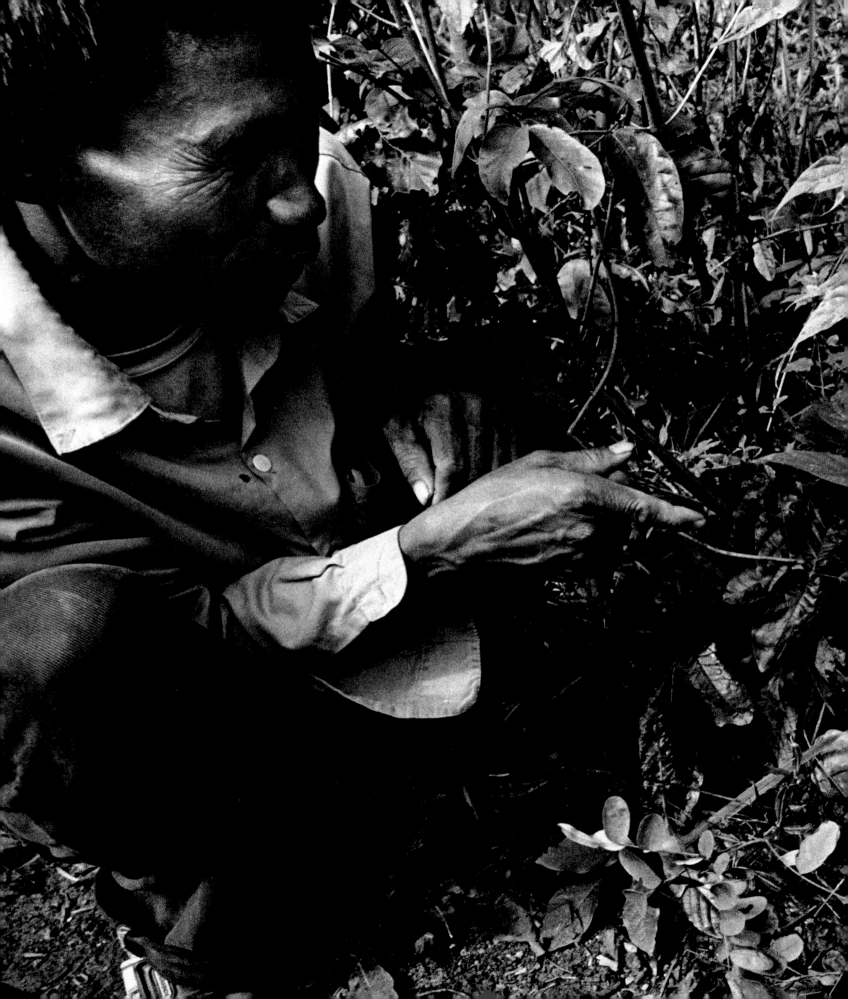

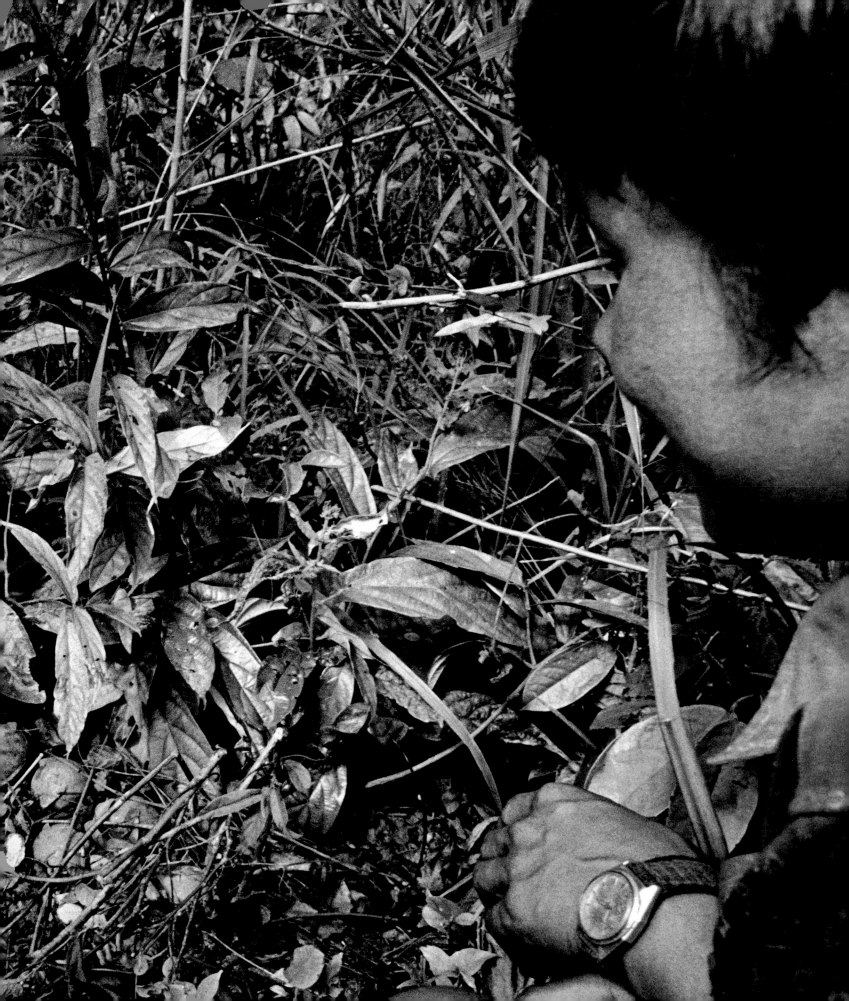

Right: Boun Doup school. Children are warned of the dangers of unexploded ordnance in a classroom supported by cluster bomb casings. MAG is clearing ordnance from the ground nearby so that a larger school can be built. Saravane Province.

Following pages, left: A farmer found this aluminium tube full of bomblets when digging a hole for a fence post. He had cut through it with his spade.

Following pages, right: MAG staff inspect an abandoned SAM-2 surface to air missile. Two villagers were killed here a month ago. They tried to cut off pieces of the missile to sell. It is believed that some of the highly toxic fuel leaked when they cut a hose. Both pictures: Khammouane Province.

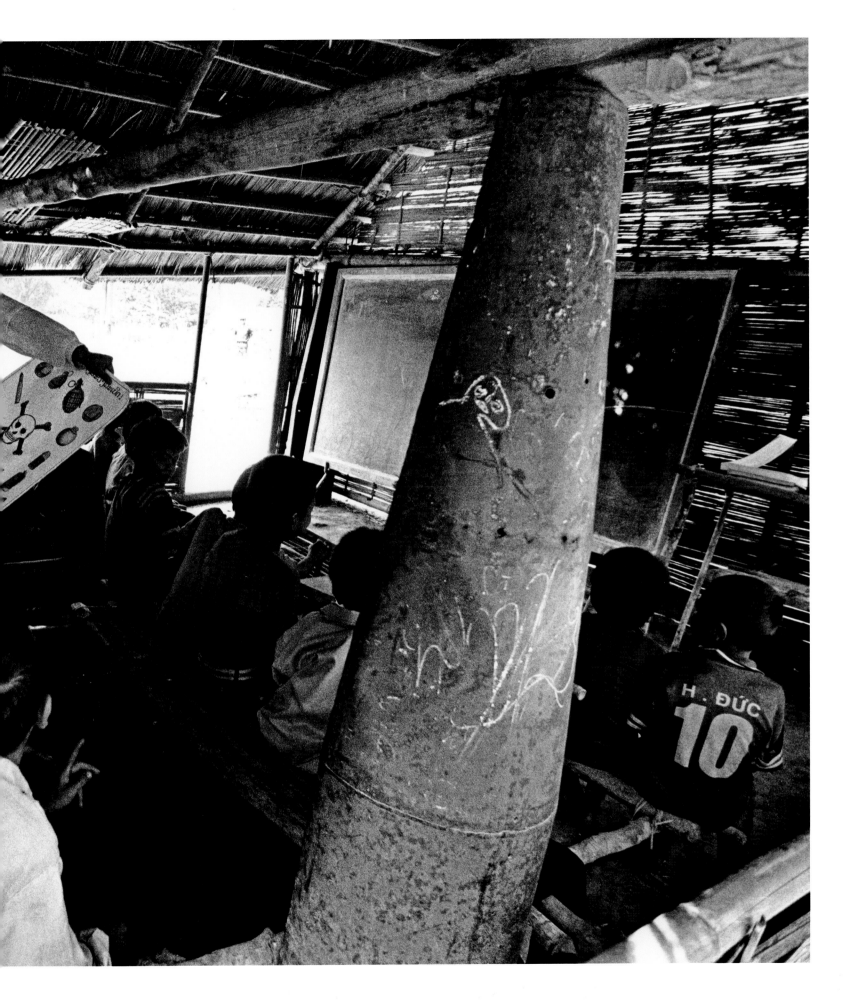

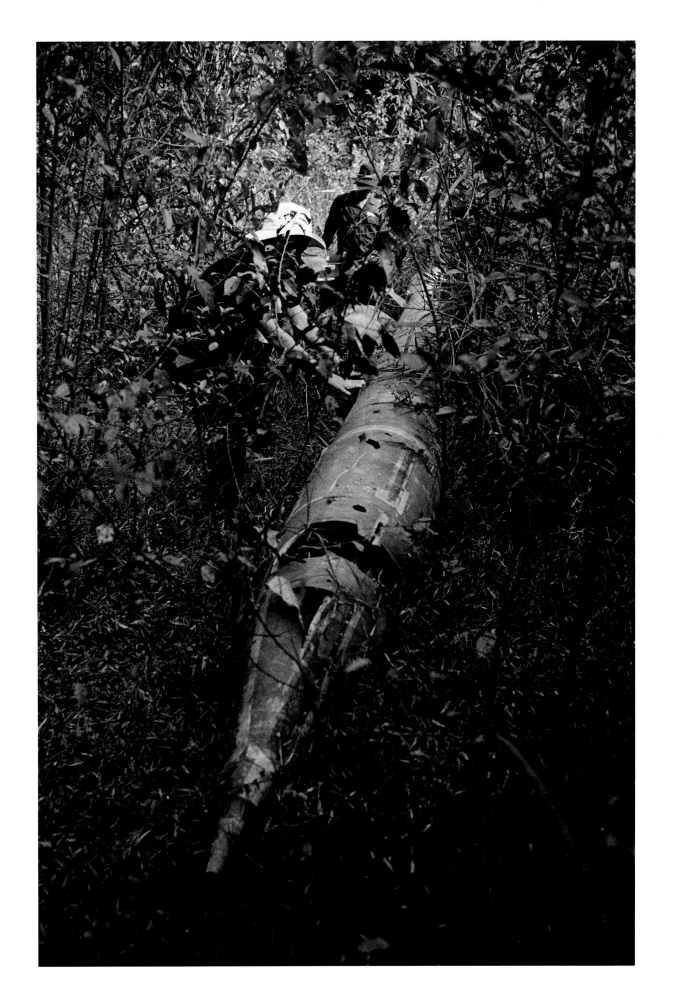

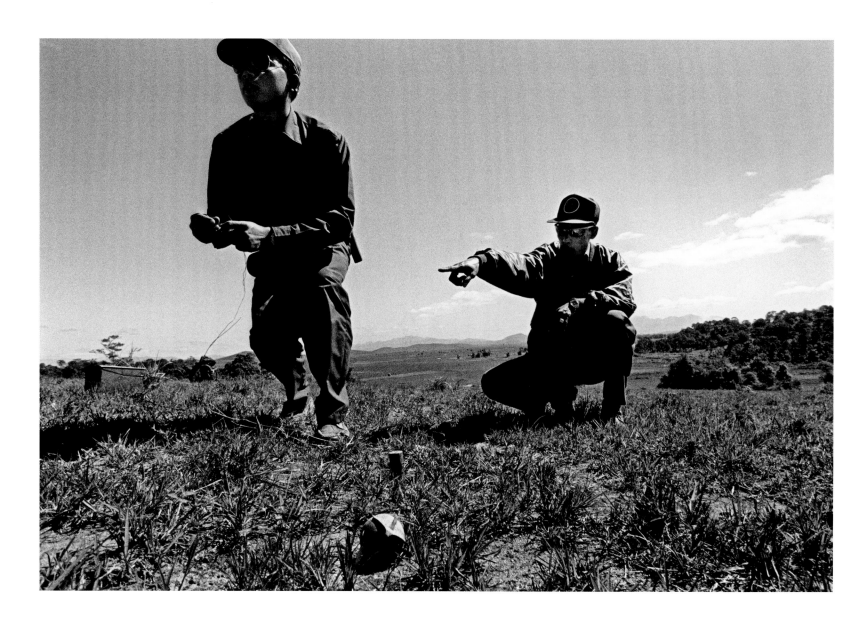

Above: Training on the job. A senior instructor explains procedures during the demolition of a bomblet. Xieng Khouang Province.

Right: Boua Nom shows MAG staff the site where his fifteen-year-old nephew Dao was blown up taking fuses off 105mm projectiles in Phanop village. "I found these bombs many years ago and buried them in a hole I dug in the bottom of a big crater. I didn't tell the MAG teams about them – I thought they would be safe. But Dao found them with his metal detector this morning. What a tragedy!"
Khammouane Province.

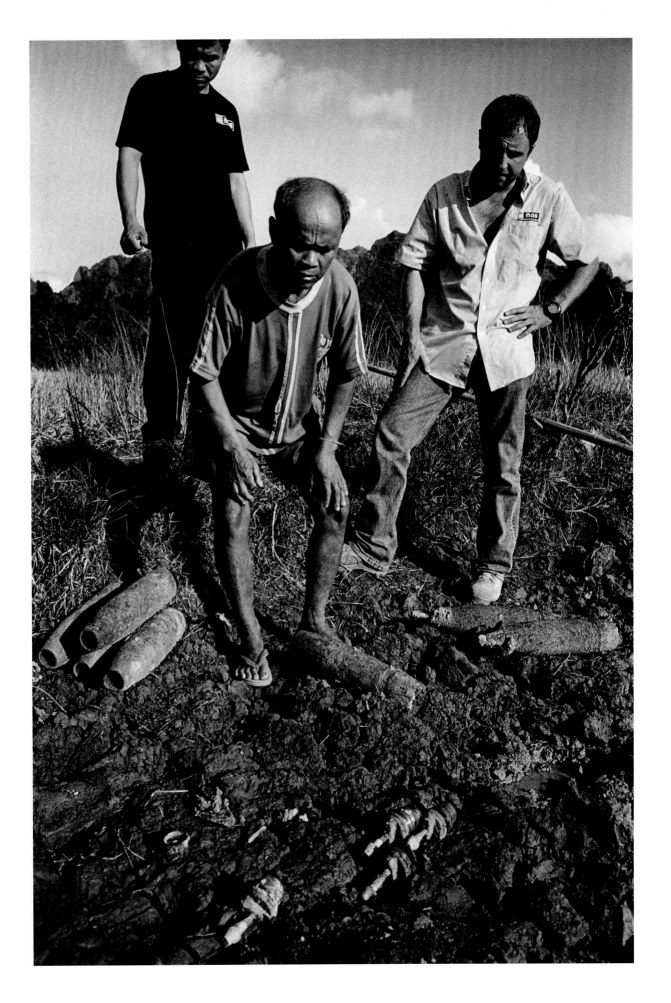

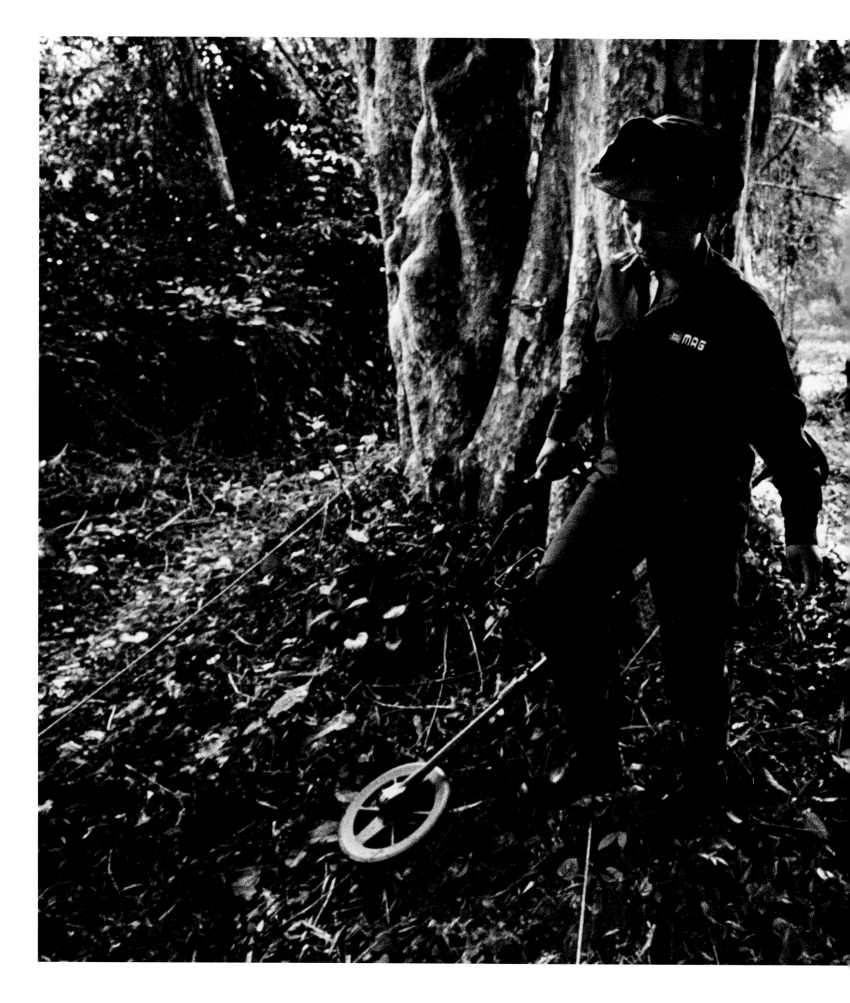

Deep search: A technician methodically checks the land for unexploded ordnance.

MAG found and destroyed more than 430 bomblets from in and around Boun Peng's house. "I knew that there were bomblets because I found some when I built my house. But I didn't know that there were so many – they even found one just below the surface under my bed." Xieng Khouang Province.

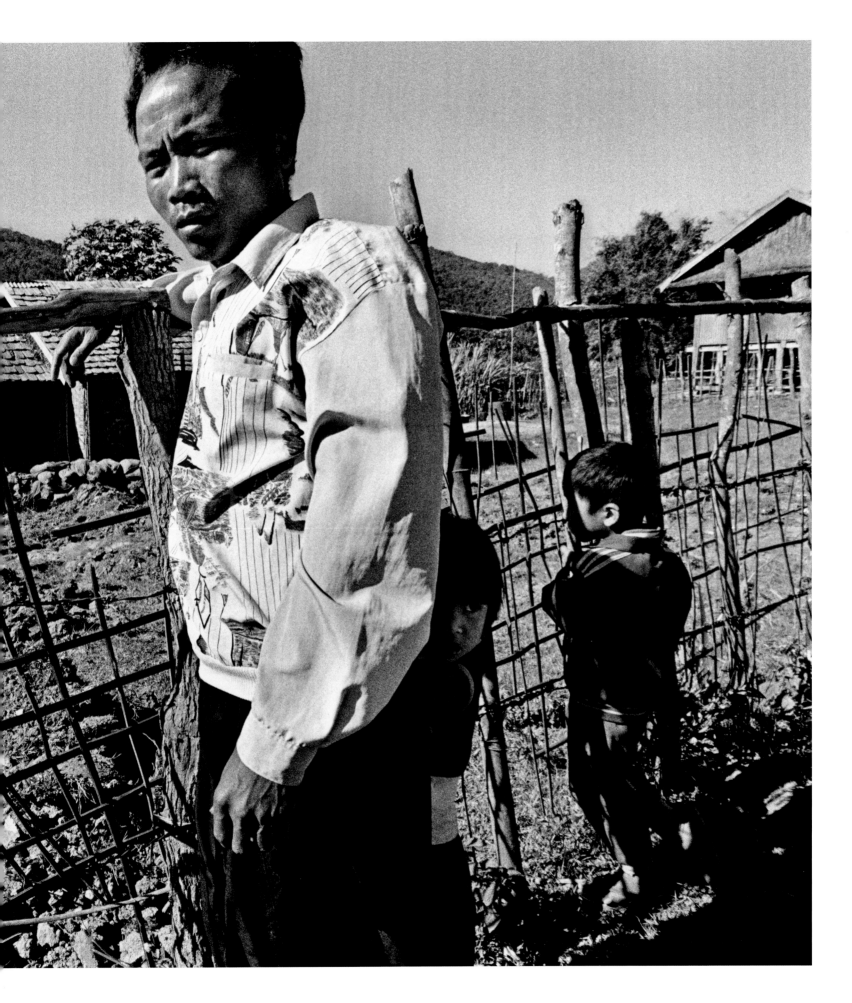

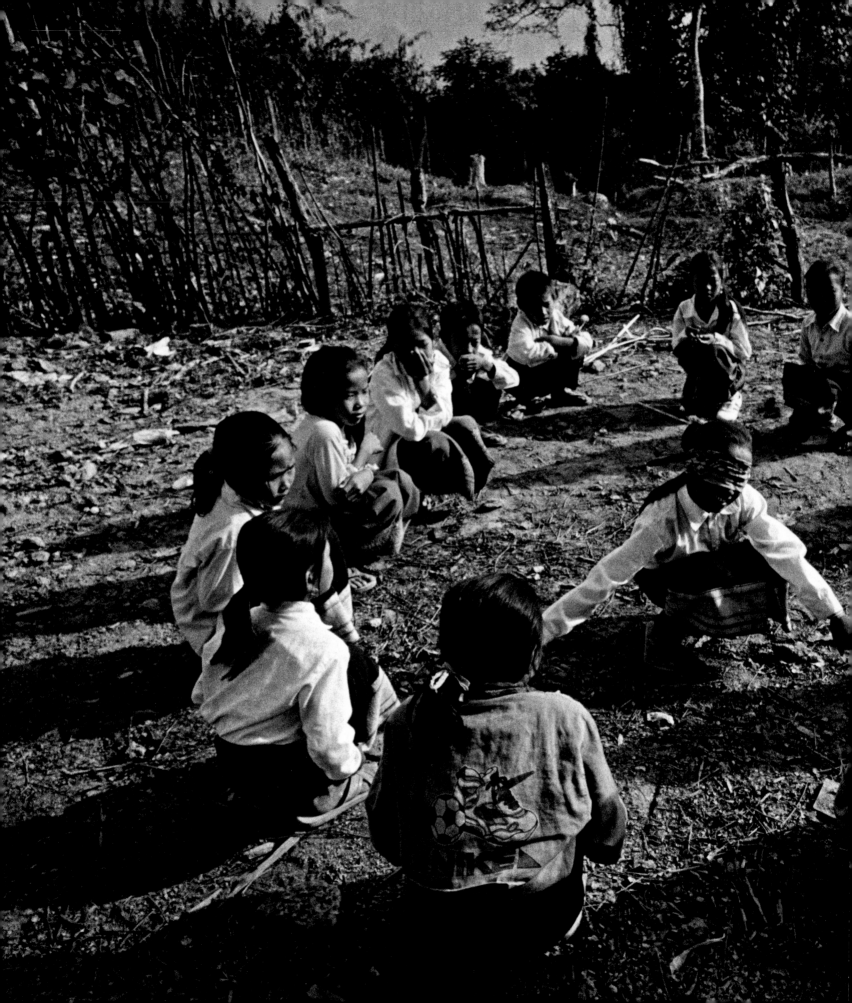

Children in the school
playground as technicians
clear the land around them.
Ban Kabour,
Xieng Khouang Province.

Following pages: Pon Toum
school, one of 115 assisted
in the province by MAG and
development partners. As a result
of the work clearing unexploded
ordnance, drilling water wells
and rebuilding schools, pupil
attendance has risen by more
than 30 percent. This project was
funded by the U.S. Government.
Khammouane Province.

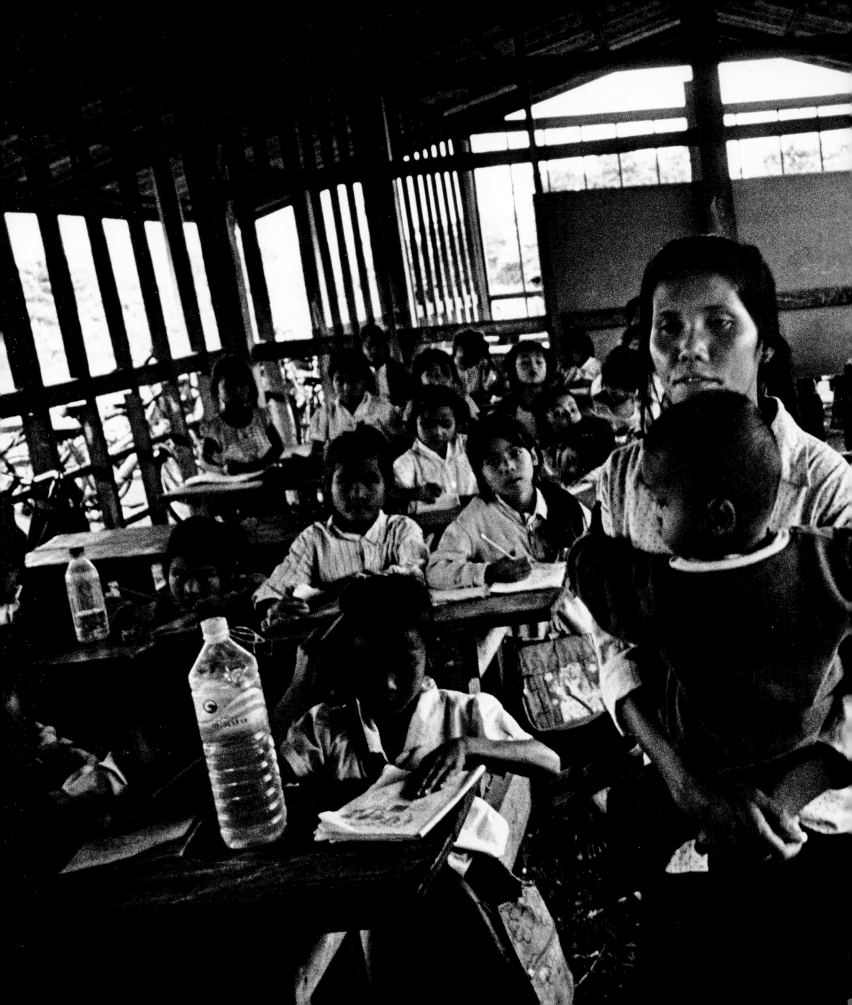

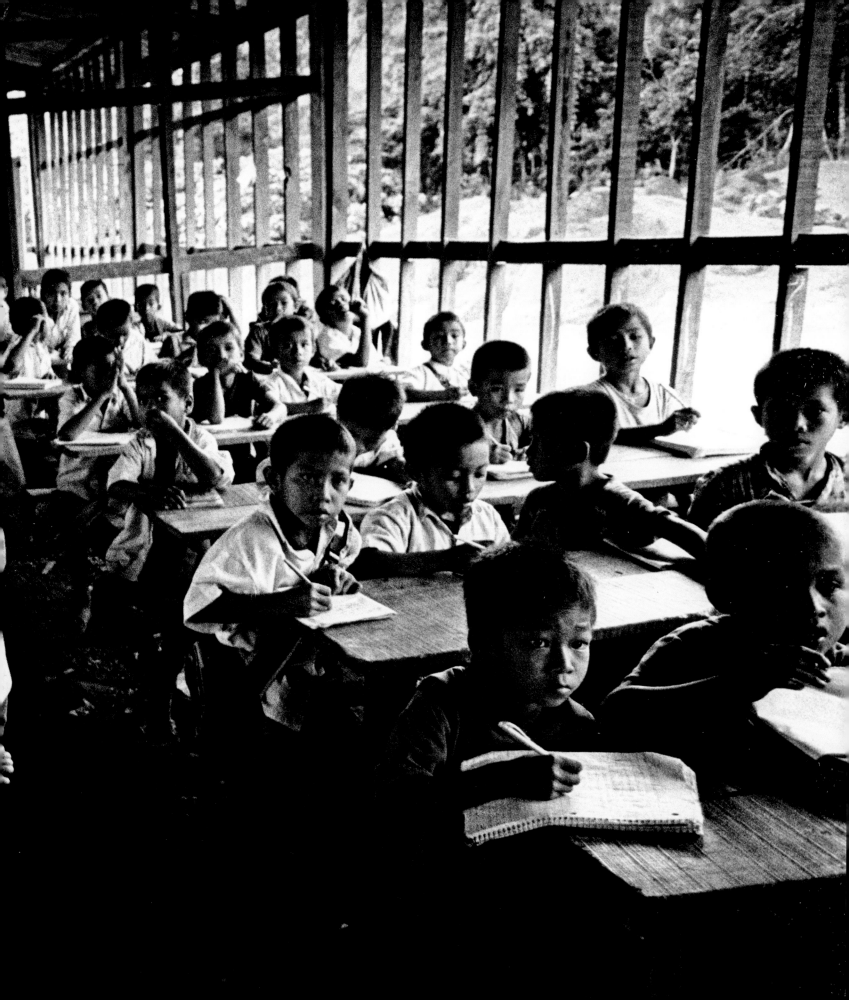

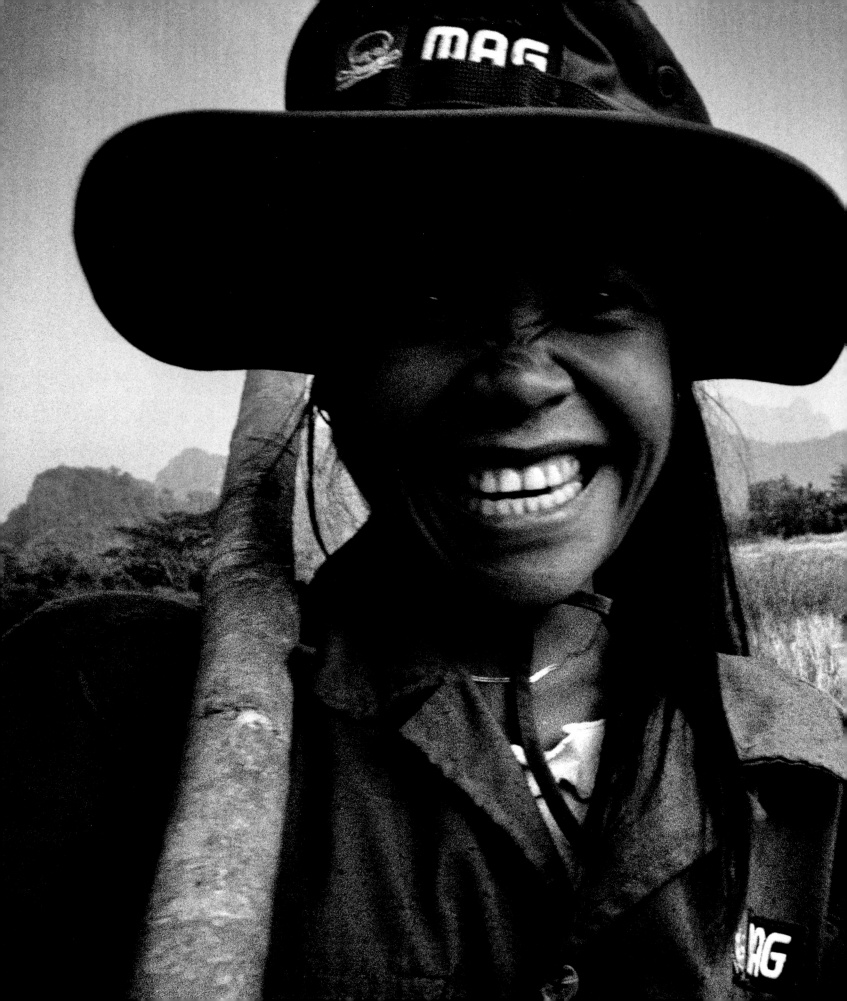

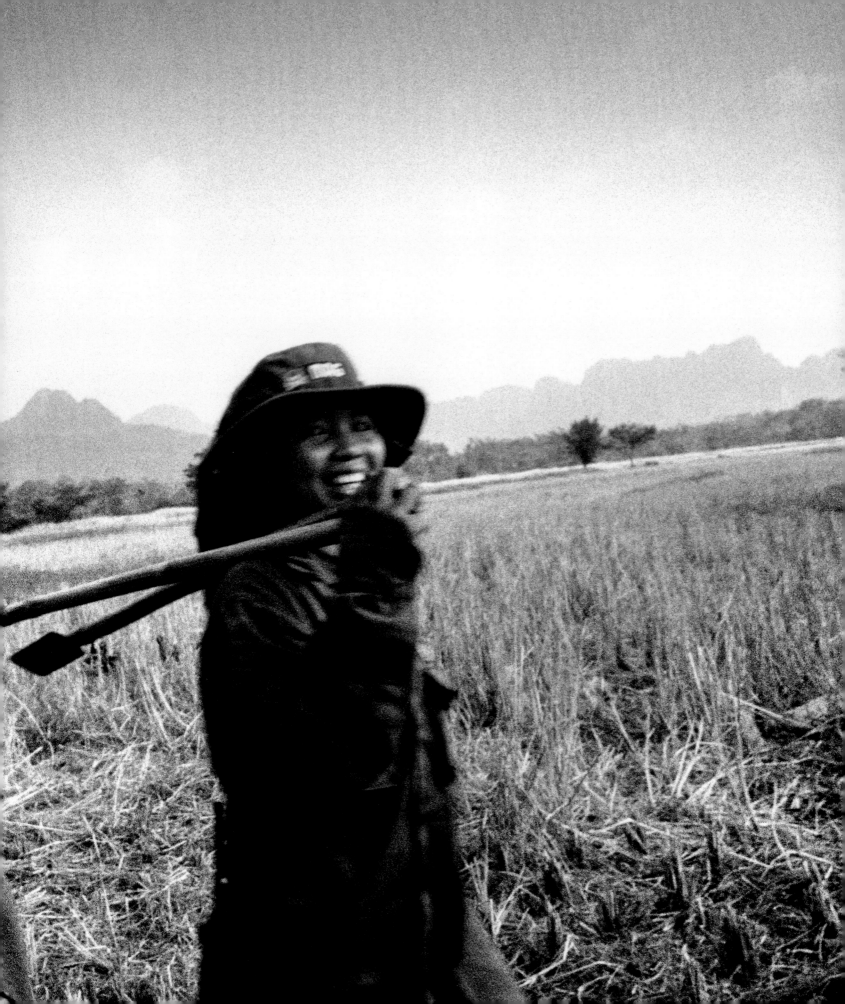

Previous pages: One of the MAG teams arrive at the village. This team is mostly female. Khammouane Province.

Right: This bomb was uncovered and the fuse was inspected by a MAG Technical Field Manager. The fuse was determined to be dangerous and the bomb not safe to move. A little later the tail fuse was blown off using an explosive charge known as a 'cracker barrel'.

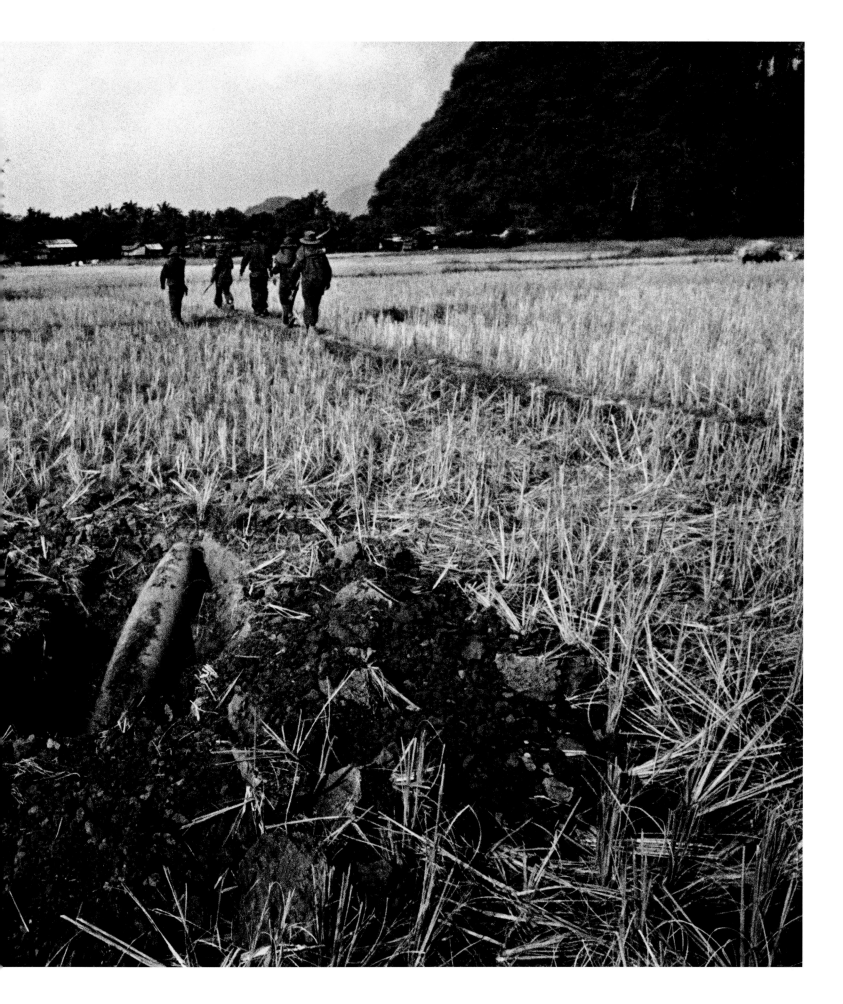

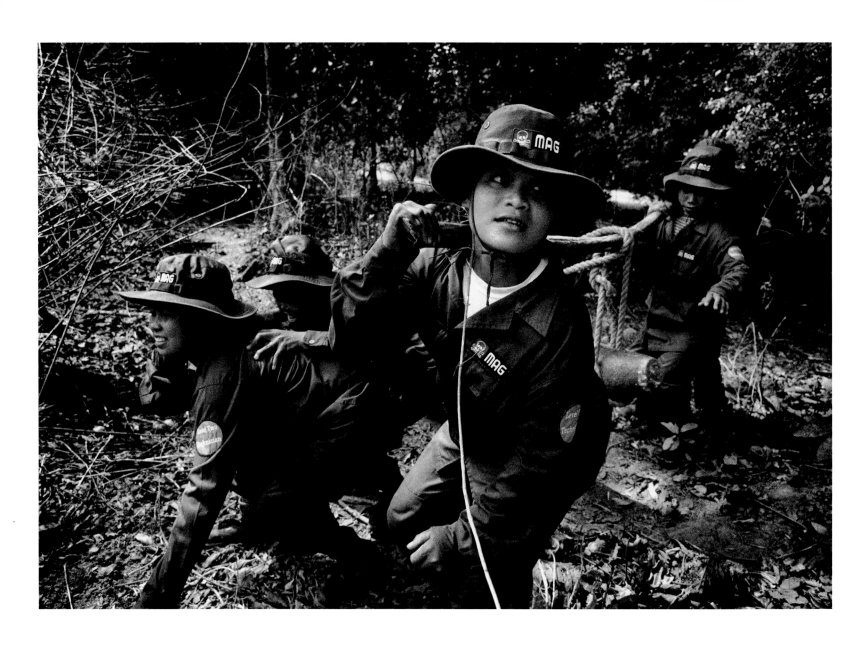

After being made safe, a 500lb bomb is moved to a truck
by the team. Khammouane Province.

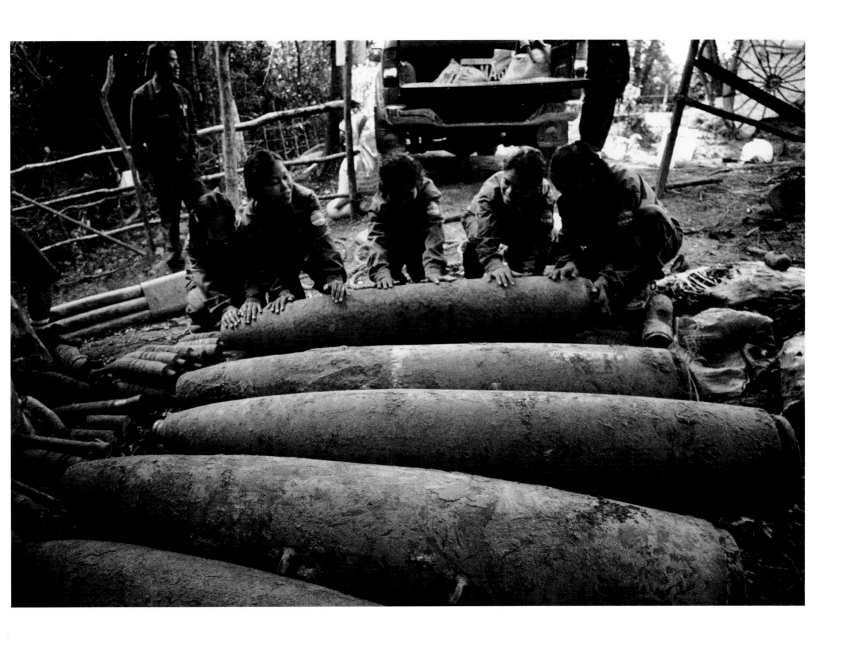

Another bomb is rolled into the unexploded ordnance store.
On the first day villagers showed the team nine large bombs.
All will be blown up and destroyed in a controlled demolition.
Phanop village, Khammouane Province.

Mr Lee showed the MAG team large amounts of unexploded cluster bomblets he and other villagers had found whilst cultivating the fields. Khammouane Province.

Following pages:
One hundred and one cluster bomblets dropped about 40 years ago are destroyed in a controlled demolition. The village have lost 10 people to unexploded ordnance and were very worried about these bomblets. Khammouane Province.

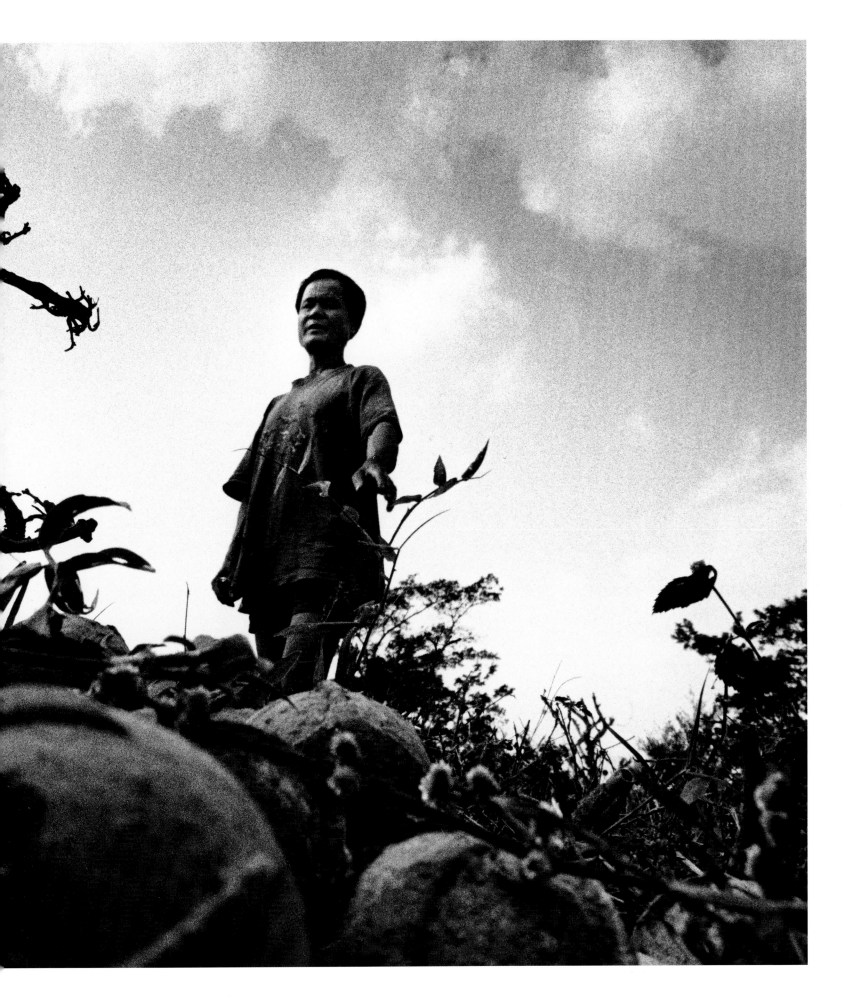

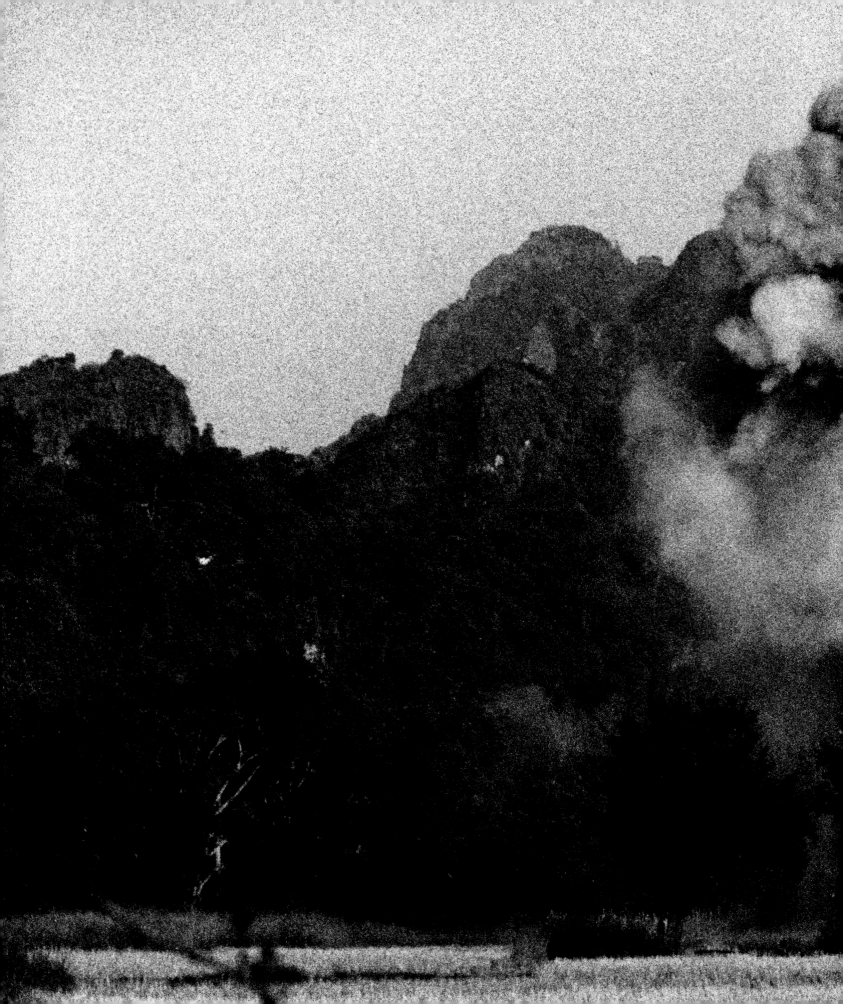

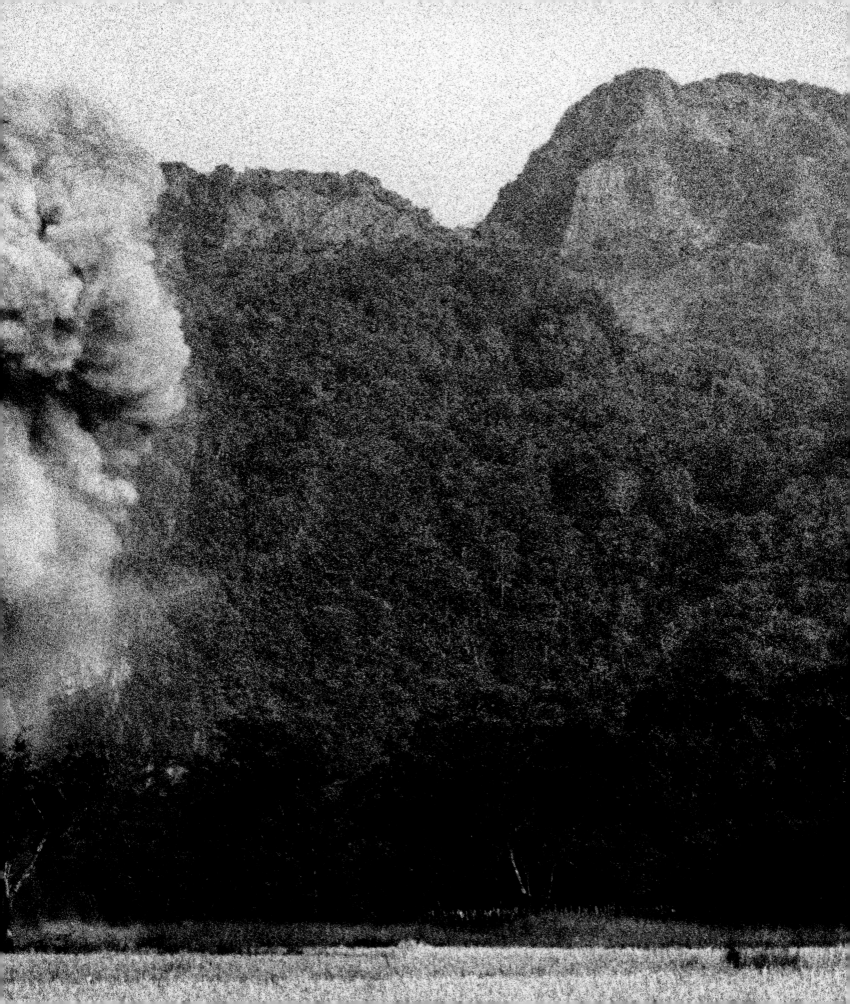

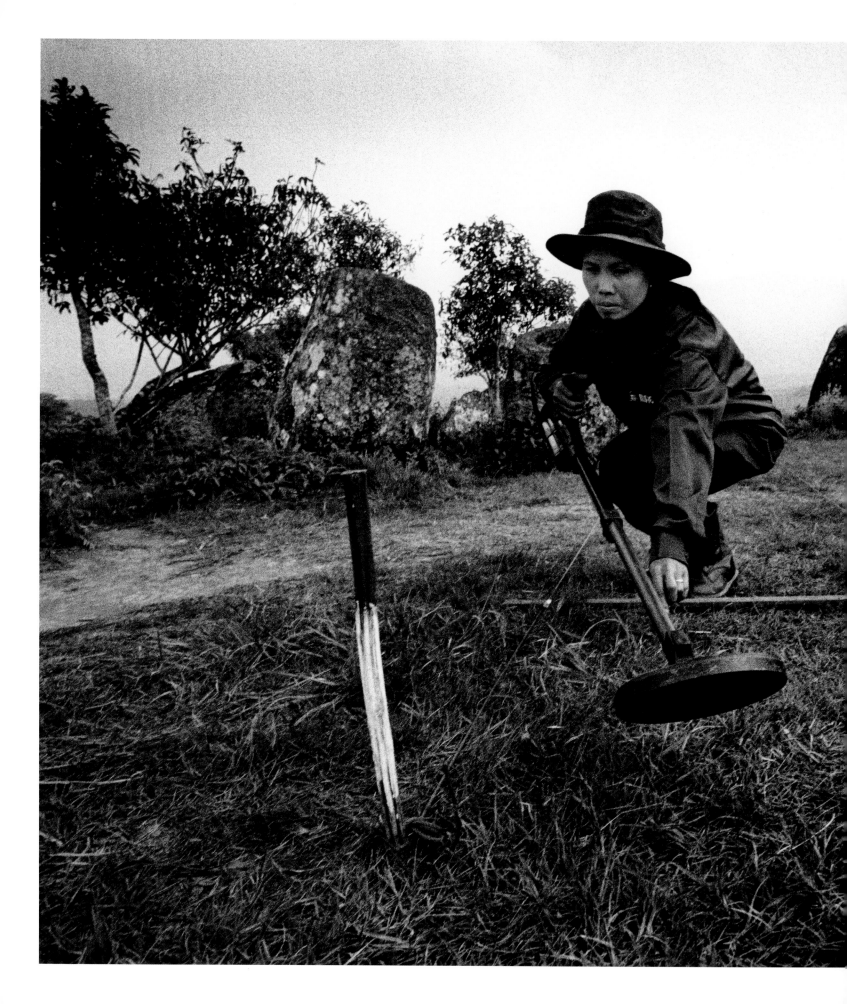

In partnership with UNESCO, teams work to clear the Plaine des Jarres of unexploded ordnance. This project, funded by the New Zealand Government, was intended to help secure World Heritage status for the jar sites. Here Boua Van is marking the spot where her detector signalled a metal item. It could be a piece of fragmentation, a nail or a cluster bomblet. Xieng Khouang Province.

Following pages:
High explosive anti-aircraft rounds and mortar bombs found around the jars are destroyed in a controlled demolition. Xieng Khouang Province.

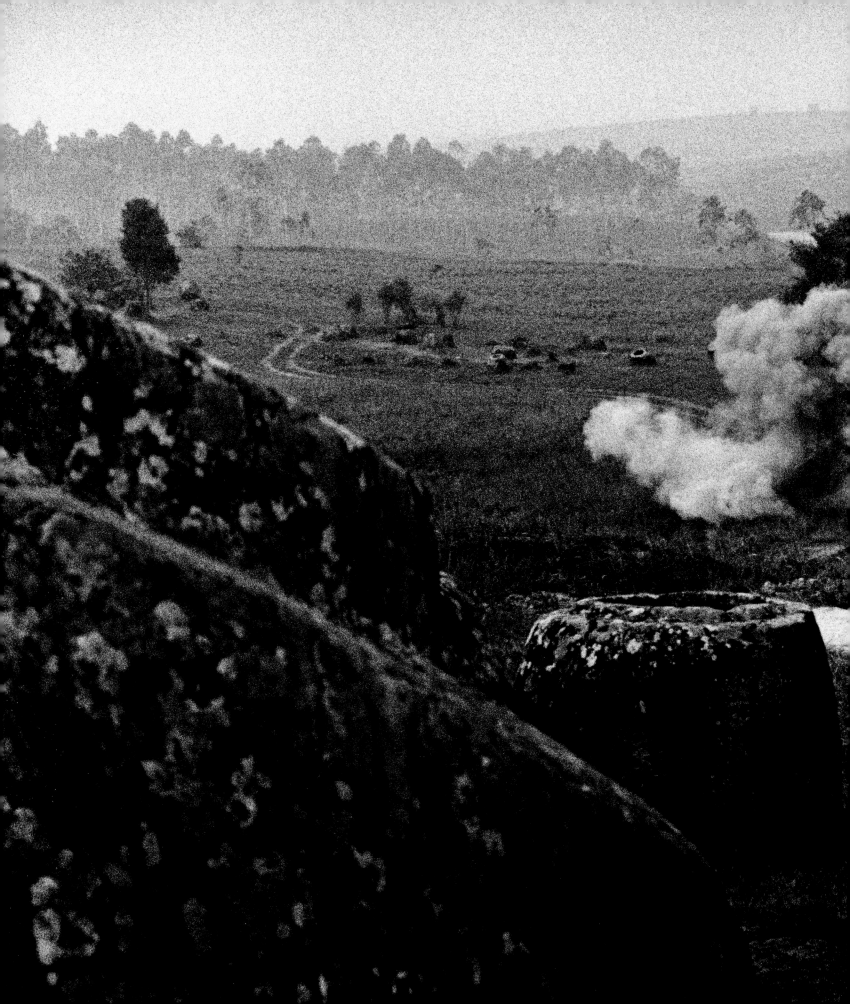

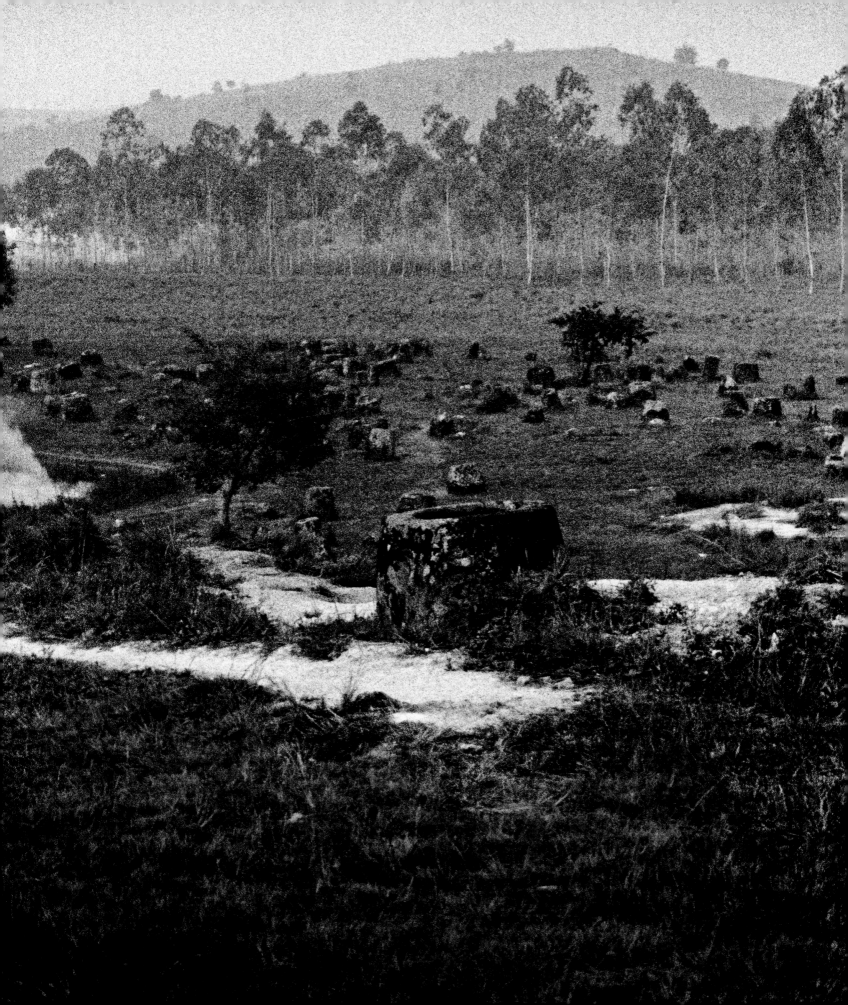

Bombs and elephants on the surface of the moon

The population of Phanop village cower under a rocky overhang behind a mountain close to their village. Some of the younger children are crying and some are covering their ears in anticipation. The parents are calmer, but anxious, and the older people recount the last time they were hiding here, more than 30 years ago. A voice from a radio counts down: Sam! Song! Neung! A huge reverberating explosion shakes the ground and echoes off surrounding mountains followed by a sudden rush of air. A 1,000lb guided bomb has just exploded nearby.

Around 200 people have come here to protect themselves from shrapnel travelling at ballistic speeds as bombs explode. This is the very spot where villagers spent much of their time between 1964 and 1970 hiding from frequent air attacks. Today aircraft are not dropping bombs. The people are here because a MAG bomb disposal team is destroying the unexploded bombs littering their village.

Nestled between towering mountains close to a pass across to the nearby Vietnamese border, Phanop village was more ravaged by the war than most. The area formed a bottleneck for Vietnamese forces crossing into Lao PDR. It was the most northern artery of the infamous Ho Chi Minh Trail and was relentlessly bombed for more than six years.

Now sixty-six, Nyot Keomanee remembers the war years with clarity. "I was wounded over there trying to get to this cave," he said, simultaneously pointing to the river eight metres away and pulling up his T-shirt to show a mass of scar tissue. "It was so terrible, many villagers died."

Sixty-two-year-old Ngorn joins the conversation: "I was wounded too. We had so little food and the children cried all the time from hunger. The Vietnamese gave us rice, one kilo for 10 people per day, and the rest we had to forage for in the forest – mostly leaves and roots. But we couldn't cook. If the planes saw smoke they would bomb. Sometimes there would be no warning. They would come as low as the bamboo, then boom – they would drop bombs. Other times they would be very high, dropping lots of bombs."

Phanop village is in Boualapha district, Khammouane province. Records show that over the period there were 36,000 bombing missions in this district alone. The evidence in the village is still startling. Huge bomb craters are everywhere. Some are used to breed fish, others serve as wallowing holes for the buffalo.

Every house utilises the remnants of war. Every bucket and watering can is made from aluminium rocket canisters and flare tubes, many with warning stickers such as 'set fuses' still attached. Alloy tubes for

dispensing cluster bombs are fashioned into ladders, aircraft fuel tanks into boats. Hundreds of casings from cluster bomb units (CBUs) surround the houses to prevent rainwater eroding the ground. Some are lined up to make fences or laid on the ground to serve as pig troughs. A wing of a U.S. fighter jet lies under a house where it fell from the sky more than 30 years ago. Villagers said the plane exploded in mid-air and that at least another four were shot down around here.

Many of the remnants of war are deadly. Experts say up to 30 per cent of ordnance fired or dropped will fail to explode as planned. One CBU scatters nearly seven hundred tennis ball sized bombs – each one with a killing range of five metres. A glance around the village at the hundreds of empty CBUs is enough to realise the scale of the problem here. Many have died. The risks are high when hoeing the ground for agriculture and children are injured nearly every week in Lao PDR playing with these interesting-looking metal balls.

Many people go about their daily chores – preparing their land for agriculture, digging for edible roots, searching for valuable scrap metal – knowing that their trowel or spade might set off a deadly explosion. This is an intolerable situation but there is a solution. The explosive remnants of war can be found and destroyed.

MAG has been working in Lao PDR for more than 15 years finding and destroying unexploded ordnance and running awareness programmes to help people minimise the risks of an accident.

Today in this remote region of Lao PDR, Phanop village is being visited for the first time by a MAG team. The team comprises five women technicians, a supervisor, a medic and a driver. During the first day, eight large aircraft bombs and hundreds of cluster bomblets were shown to the team. Most of the large bombs were underground and had to be uncovered so that the fuses could be inspected. Some were categorised as safe to move but a number had to be made safe by removing the fuses in controlled explosions or destroyed in situ. The cluster bombs cannot be made safe and have to be blown up where they lie.

Nineteen-year-old Ponchan is one of the technicians and has been working for MAG for nearly four months: "I come from Tat village about 10 kilometres from here. There is so much unexploded ordnance around and it is a big problem. I am very happy that I have this job, I can support my family and at the same time clear the fields and villages and save lives." Ponchan's family are farmers, she has four brothers but now she is the main breadwinner. They grow rice, vegetables and potatoes and have three cows, two buffalo and some chickens. They also breed fish in a bomb crater. "In a good year my family makes about 10,000,000 kip ($1200) but often it is more like 4,000,000." Ponchan's $95 per month salary

goes a long way to help her family. "We don't have problems with money anymore, when we need soap or sugar we can buy it and we are saving up for a generator and a tractor."

One of the aircraft bombs that MAG found proved to be a big problem. It weighed 2000lb and was too large to move by hand – it was impossible to get a truck across the river, through the village and across the rice field to where the bomb lay. The experienced team leader successfully used an explosive charge called a 'cracker barrel' to blow the tail fuse off the bomb. This made it safe to move.

An elephant called Bounmar was recruited for the job. The whole village watched with delight and amazement as Bounmar heaved the huge bomb across the rice field, through the village and across the river.

Back in the cave the village headman is very complimentary about MAG's work: "At last something is being done here to make this land safe. Unexploded bombs have killed 10 people here. Just a few months ago a boy was killed in the village digging for crickets. When the war finished, this place was like the surface of the moon and now it has come back to life. But death still lurks under the ground. The team here are changing people's lives. Every time we dig the rice paddies we have been afraid. Soon things will be different."

In all, three of the bombs have either been made safe or destroyed. The people begin to file along the narrow path back to the village, the children running ahead making clouds of dust. "This is a good day for the village," said Ngorn smiling. "A very good day."

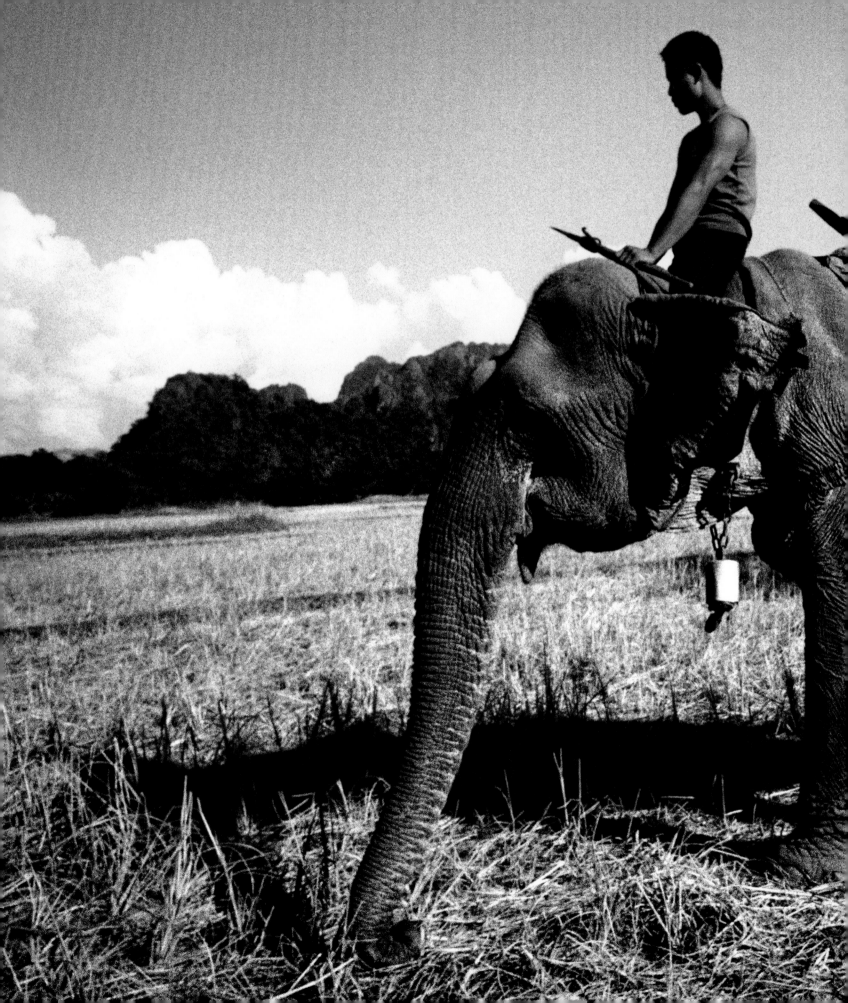

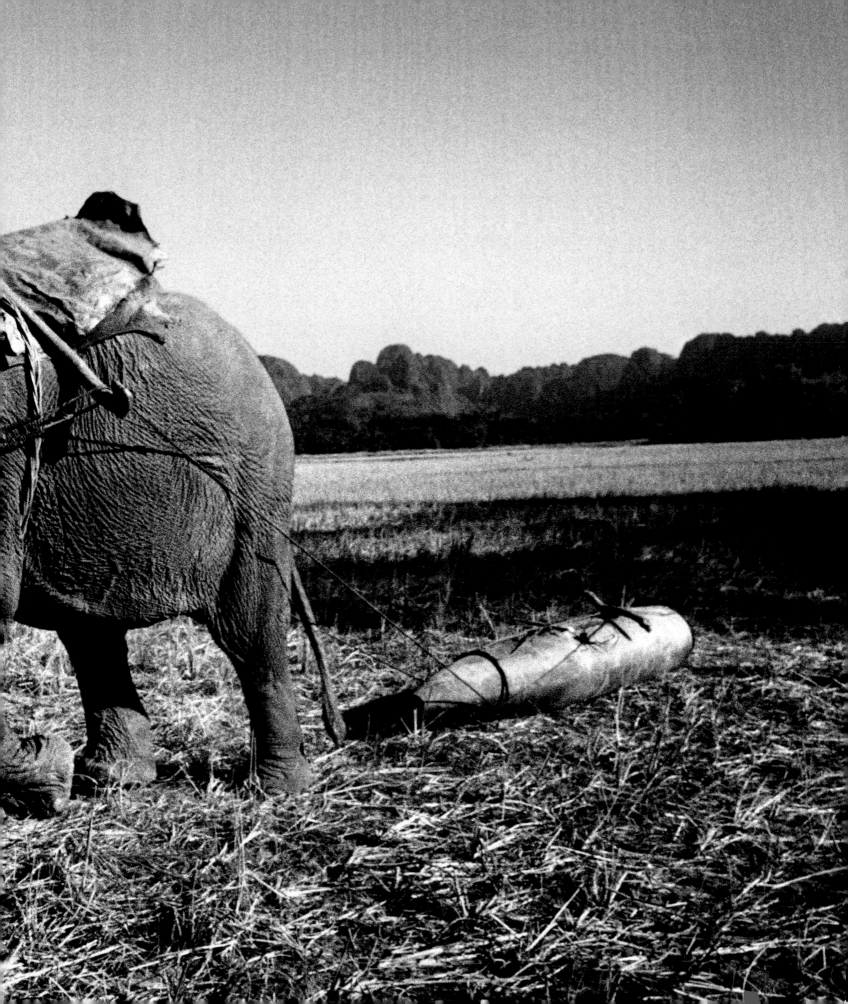

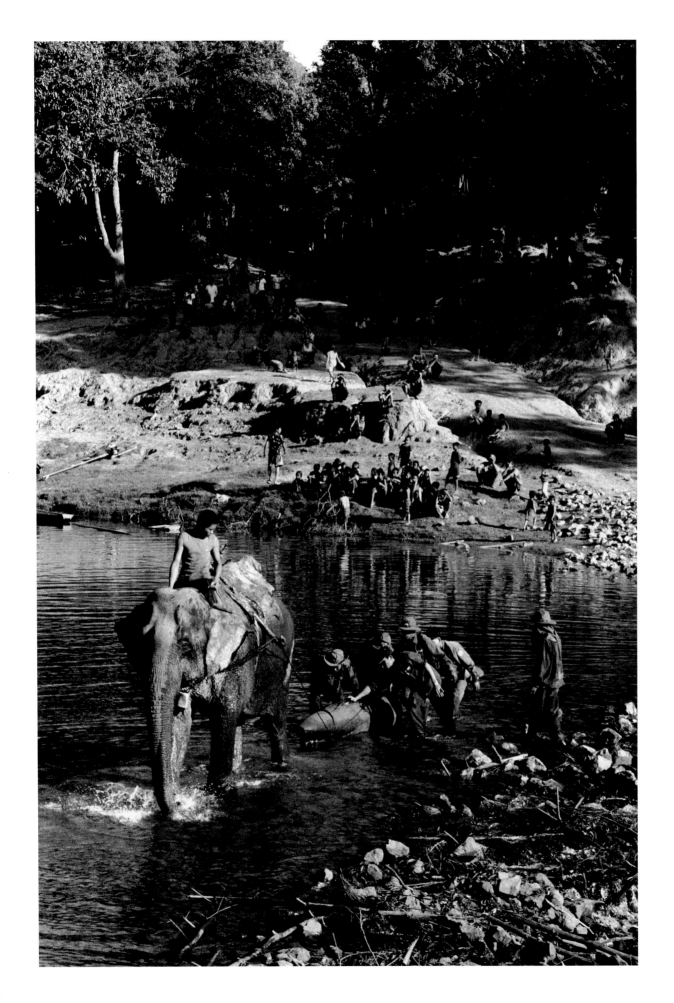

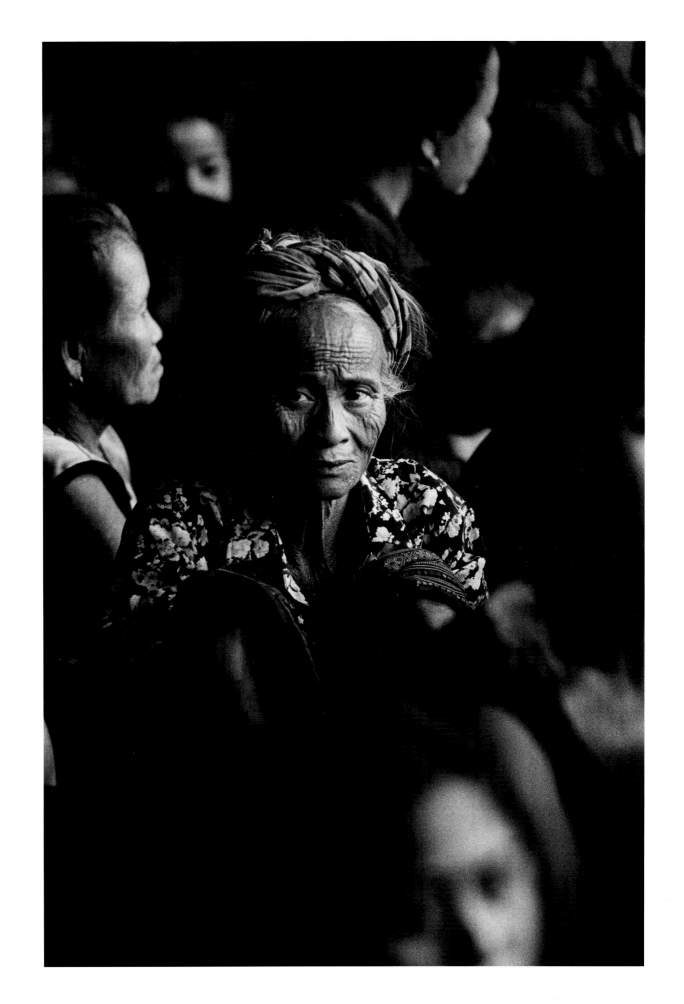

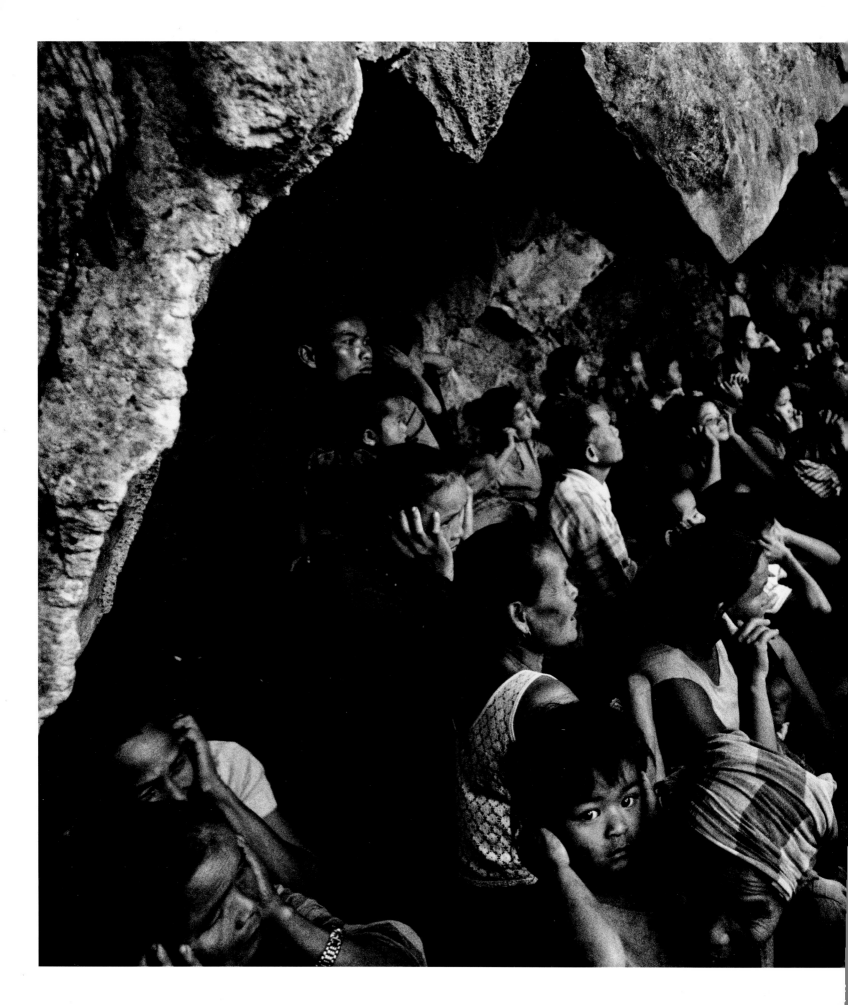

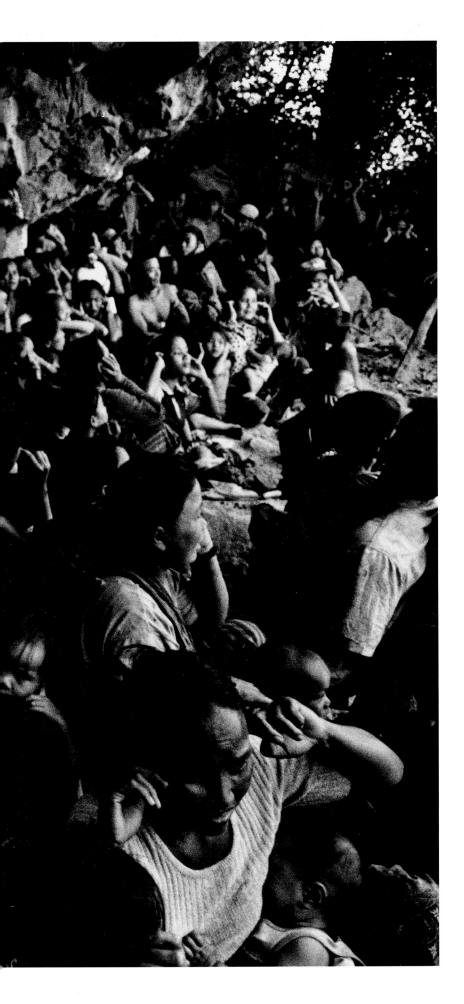

Previous pages:
MAG recruits the services of Bounmar the elephant to drag a 2000lb bomb through the village and across the river. Bounmar was the only option as a large truck would not be able to drive through the village and reach the field where the bomb lay.

Previous pages, left and right: Villagers watch as Bounmar drags a bomb across the river.

Left: More than two hundred people have gathered here to protect themselves from shrapnel travelling at ballistic speeds as MAG detonates war-era bombs. This is the very spot where villagers spent much of their time between 1964 and 1970 hiding from air attacks. Today aircraft are not dropping bombs. The people are here because a MAG bomb disposal team is destroying the unexploded bombs littering their village. People cover their ears for an expected explosion. All photos: Khammouane Province.

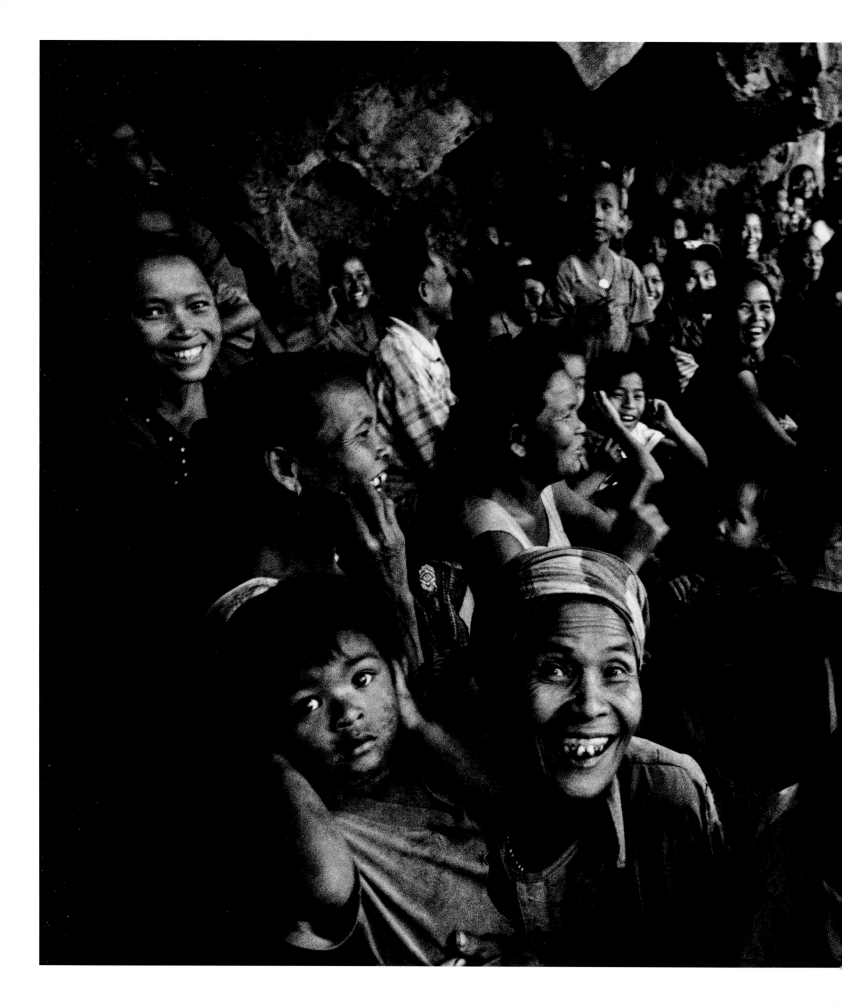

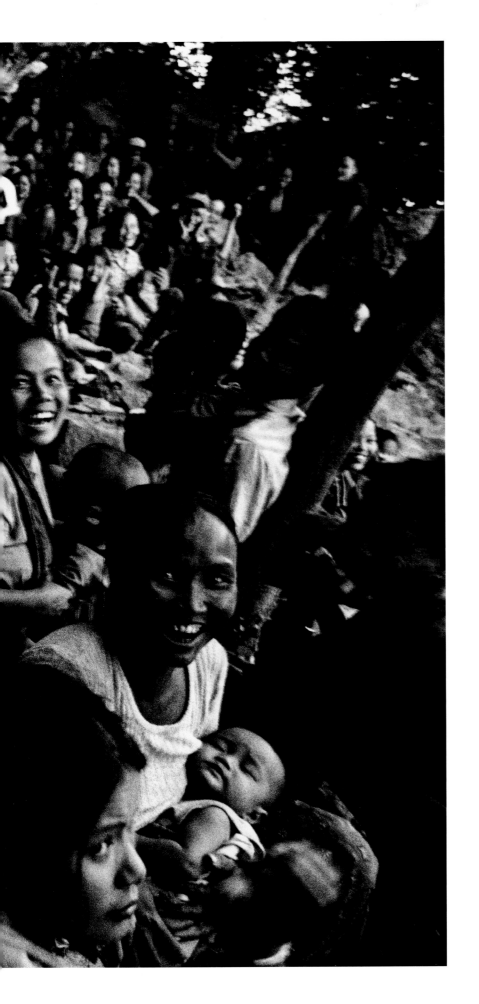

Relief.
A 1,000lb guided bomb had
been safely destroyed nearby.
Khammouane Province.

Following pages:
The crater where the
massive bomb was destroyed.

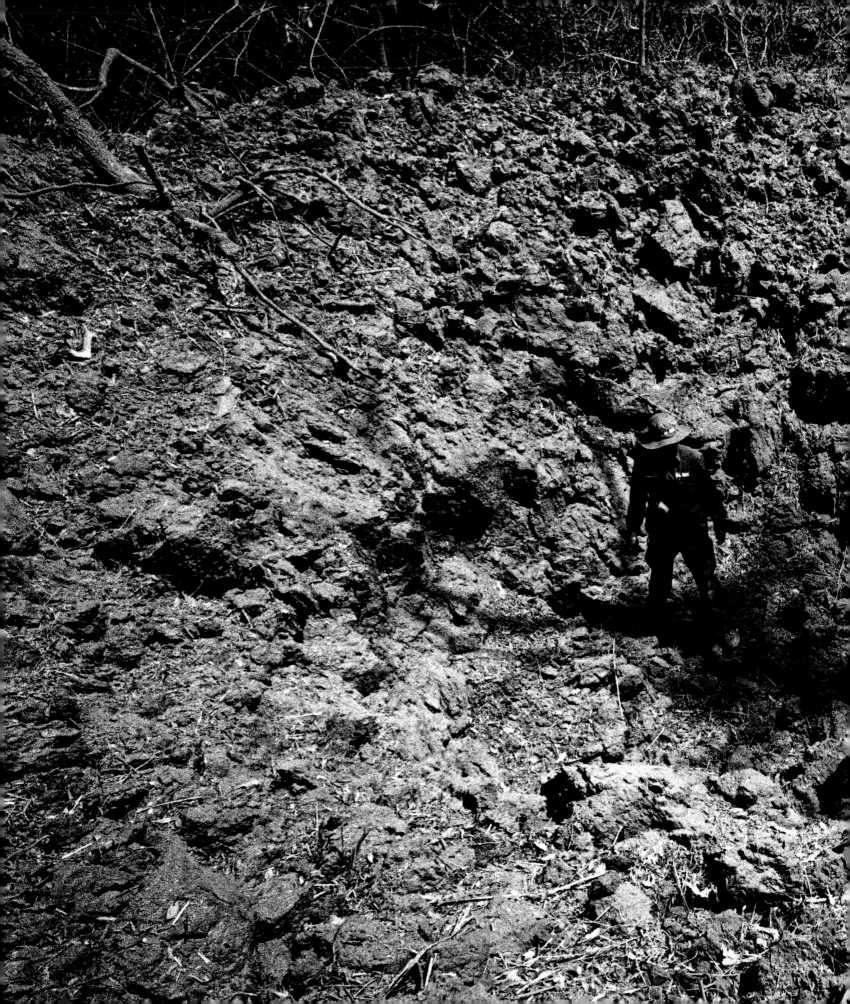